*Calamity Jan and the Russian*
A Memoir

*For Sue* :)

*Calamity Jan*

# Calamity Jan AND THE RUSSIAN

BY

## JAN PIERSON

Gypsy Shadow Publishing

Calamity Jan and the Russian
by
Jan Pierson

Gypsy Shadow Publishing, LLC
Lockhart, TX
www.gypsyshadow.com

Library of Congress Control Number: 2012948024
eBook ISBN: 978-1-61950-095-2
Print ISBN: 978-1-61950-106-5

Published in the United States of America

First eBook Edition: August, 2012
Second eBook Edition: September, 2012
First Print Edition: August, 2012
Second Print Edition: September, 2012

# DEDICATION

To Valentin

# TABLE OF CONTENTS

*St. Petersburg, Russia 15 September, 1998*

*You are so pretty! I want to be with you more and more, to share happiness and troubles with you. I feel trembling inside me as in youth and hear whispering that I mustn't lose you. I'm sure we will be good partners, real friends and more. I'll try to do everything for this and the Father help me. I'm eager to come as soon as possible!*

# Prologue

*19 January, 1999*

Glass partitions separated those of us in the outer waiting area from the immigration lines at the Seattle-Tacoma International Airport. I scanned the lines moving slowly through security, watching for the face I'd seen only from photographs.

Suddenly I saw him moving closer to the final gate. I braced myself against a person or a wall (I can't remember), hoping I had the strength to keep from fainting. *It's him. Oh God, it's him . . .* I can't remember anything else, except that he was slender and dark like his pictures and his eyes were blue. Baltic blue. He smiled and walked toward me, his chestnut-brown hair illumined by the glare of glass and lights from the security platform above. *God, I'm going to faint . . .*

But I didn't. He set his hand-held luggage down and we embraced, then drew back and faced each other. His blue eyes didn't hold mine as I'd dreamed they would at our first meeting. There was no spiritual connection.

None.

Nothing.

I reeled, listening to his charming accent, listening to his words fall like broken glass on the hard tile beneath our feet. I tried to speak, but my words jammed against the back of my throat.

What was wrong? Was he nervous? Afraid? *Disappointed?* He was good-looking, charming, energetic, but it was as though I was in the presence of a stranger from Siberia. Suddenly I wanted to run. Did he feel the same? *His eyes are empty. Cold.* Where was the man I'd been corresponding with for over a year—the man I'd begun to love through his tender, poetic letters?

*Valentin, where are you?* I cried out in anguished silence, feeling a wall that was colder and more ominous than the Iron Curtain. We walked toward the baggage claim; his wide smile, charming Russian accent and animated demeanor helped in a way, but once we gathered his luggage and entered the parking garage, the truth hit like a slab of gray cement. *This Russian man—this stranger—is coming home with me and I'm not sure I'm ready for this.*

Had we both made a terrible mistake?

*Oh God, what have I done?*

# CHAPTER ONE
## The Volga in Springtime

*Your vision will become clear only when you look into your heart.*
*Who looks outside, dreams. Who looks inside, awakens.*
—Carl Jung (1875-1961)

We met by accident, believing it wasn't an accident at all.

*Fate. God. Destiny?*

He was slender, ruggedly good-looking and well educated, a Russian man nine years my junior. Valentin Gudkov. I even loved his name. I loved everything about him, including his *Russian-ness.* Our phone conversations enchanted me, his accent and charm threw my sensibilities into a spiral downward. Or up. I didn't know and frankly, it didn't matter.

*The Miracle is with us, Kiska,* Valentin had said in one of his letters a few months before. *I love you.*

My eyes filled as I held his letters against my soul. The intoxicating new dance had begun, much to the dismay—even warnings—of a few friends and family members. *He's younger and he's a Russian. Do you have any idea what it's like living with someone from another culture? It's vodka and cabbage, Jan. Are you sure you're ready for this?*

*I'm ready. Don't you know I've been waiting for this all of my life?*

I remember the first photograph he sent me from his summer dacha. The broad shoulders and handsome profile leaned toward his grandson as he helped him carve an object from a piece of wood. The image fell into my soul, and there was no turning back.

Some might say I was old enough to know better. By the time a woman is 60, she has learned how to face her shattered fairytales and get on with life in a sensible way. Although my 30-year marriage had ended twelve years before, I began putting the pieces back together; returning to college, getting my degree in psychology and criminal justice and carving out a career. Just because Prince Charming galloped off on the white horse with another princess didn't mean my life was over. Once the kicking and screaming died down and the clutter of brokenness began to take on surprising new shape and form, I realized how fortunate I was. In so many ways my life was richer than ever before. Still, in spite of all my accomplishments—including my three supportive children, successful career as a writer and writing instructor, a joyful onslaught of grandchildren, loyal dog, wonderful friends and family—there was still something missing.

The unbidden feelings came quietly, often during the long winter evenings as I snuggled on the sheepskin rug by the fireplace with a book or my thoughts. *What would it be like to be stroking a man instead of my dog?* Sometimes that small, quiet ache knotted even tighter when I walked along the water's edge and watched couples walking hand-in-hand—couples who didn't care as much about the sunset as they did each other. *God. There is something so beautiful between them.* Usually the tears and unspoken longing lingered behind my lids until I returned home and crawled into my empty bed. I didn't want to accept or embrace those tears and those feelings in the deepest place inside of me because I had come so far during those long years of finding my way out of a lonely, empty marriage into a life of strength and personal peace—a new life where I began to know and value myself as never before. Still, in spite of so much richness, there was something missing.

Then Valentin Anatolyevich Gudkov entered my life.

I was in the process of launching the first book in a projected ghost town mystery series for young readers and had invited this fascinating Russian man to help me translate and market the book in his native country. *Calamity Jan,* a pen name I'd borrowed from Calamity

Jane, (wild woman of the West) began to feel oddly appropriate. *Calamity, what are you doing?*

Of course I was old enough to know better, and what could be better than this?

We met through a mutual friend and neighbor, Irina. Irina emigrated to the United States from St. Petersburg, Russia, marrying a man I knew. I was her attendant when they were married, and we shared many delightful evenings together over sumptuous Russian meals. She and Valentin were long-time acquaintances from a village outside St. Petersburg and would occasionally gather together with other village and University friends over dinner and drinks. On one such occasion when Irina had returned to St. Petersburg, she connected with these same friends to share her new life in the United States. She showed her colleagues snapshots of her home, and pictures of her new life and friends (including me) gathered around her table back in Washington State.

Valentin noticed my picture. "Who is she?"

"She's my neighbor and writes children's books," Irina told him.

His interest was apparent. "Perhaps I might write to her?" he asked, drawing her aside later that evening.

Irina promised to inquire, bringing a few pictures of the dark-haired, blue-eyed Russian on her return trip home.

I stared at the photographs of this slim, good-looking man with strong shoulders and amazing eyes. "He wants to write me?" I asked my friend, wondering what under God's heaven could be wrong with this.

"Yes. He seemed very interested in your photograph. In you. He asked me a lot about you."

And thus began the Russian-American saga. The KGB and the FBI. The two shall be one. What could be sweeter?

The letters flowed like the Volga in springtime.

"The morning of love is the sweetest time of all," Irina said to me. It was something her mother told her once. And it was true. I had never felt so invigorated, so young, so *happy* as I did during that first year of our letters, e-mails and phone conversations. The Morning. The Expectation. The East-West sun rising on a man and a woman who were destined to be together.

5

The first formal letter accompanied by photographs arrived on a warm spring afternoon just after I had returned from a walk with my dog, Cider.

*St. Petersburg, Russia*
*9 April, 1998*

*Dear Jan. How are you? I am fine. Let me introduce myself. I am Valentin Goudkov. October 7, 1946 is my birthday. My Dad was a teacher of sports. He passed away in 1990. My Mom was a bookkeeper, now she is a pensioner and lives with me. I am single. I divorced 10 years ago. I have 2 daughters; Katia (she is 23 years old) and Dasha (she is 13 years old.) The older is the student of the Medical Academy. She was married, now she is single and I am the grandfather of Vadim. He is the pupil of a secondary school in Moscow. We are good friends.*

*I graduated from the Technical University as a physicist in 1971 and worked at the Research Institute for 18 years. My second profession is a teacher of sports. I majored in the Academy of Sports in 1980 and worked at a secondary school for two years as a teacher of physics and sports. Now I work as a marketing manager in a private firm. I like music, ballet, books and flowers. My hobbies are: sailing and gardening in summer, skiing during winter. I am fond of Nature and really relax only when I am in the country. I have traveled a little in Europe, visiting Sweden, Finland, England, Holland, Germany, Poland and Czechoslovakia in the car and by the yacht. I visited my school's friends in the United States in 1995.*

*Although our climate is not pleasant, St. Petersburg is very beautiful city in any season. There are a lot of nice buildings and palaces, squares and gardens, rivers and canals. Welcome to our city, to Russia in any time you wish. Don't be afraid.*

*I am looking forward to hearing from you soon.*
*Yours sincerely, Valentin*

*Don't be afraid?* The quiet trembling inside the deepest part of me told me that my life might never be the same again. And I was right. East and West launched a correspondence of letters and e-mails that quietly began to

shake our own little iron curtains and take us on a journey that would change our lives forever.

His photographs showed me craggy good looks and gave me snapshot views of his family and his Russian world. Although he lived in a high-rise flat in the outskirts of St. Petersburg, his smile seemed wider when he was tending his orchard and garden at his summer house (dacha) in the village, or leaping out of the sauna barefoot in the snow.

I shared a bit about my life growing up in a small town in Washington State on the edge of the San Juan Islands, describing fond memories of our primitive cabin on one of the islands where I spent my childhood summers. *Maybe our cabin was something like your dacha?* I asked in one of my letters, wondering if they had indoor plumbing or had to make trips to the outhouse like we did. I didn't know then that I was going to find out. I had no idea that sitting in an outhouse in a Russian village in November feels stunningly different when you're sixty than when you're six. I didn't tell him everything, though. Some memories I wanted to bury under the outhouse or back home under the old apple tree near our run-down garage next to the alley. It wasn't easy for me and my three siblings during the hardscrabble years when my parents struggled to keep food on the table and their marriage together; days and years when their arguments and coldness spilled over into our lives, hurting our hearts even more than the harsh words and frequent spankings. Except for my loving grandparents and best friend, Lynene, I felt so alone and responsible.

I told him the good things—about my first book series that had been inspired by these islands and those carefree summer memories, then sent him my first draft in the newest projected series—a ghost town mystery.

*20 April, 1998*

*Dear Jan. I am fine. Mom returned to the country to finish agricultural season and in two or three weeks she will be home and I will eat normally. The summer was very cold and rainy this year, but we have gathered a great number of cucumbers, currant and gooseberry, not many*

*apples and potatoes; but for two persons it is enough. You are right! Mom is very tired after grandson Vadim, but now she has a vacation. She know about our friendship and correspondence. She is glad and grateful to Irina for us!*

*I've read your book about the ghost town with great interest. I love it. I'm sending you a small gift.*

*A gift?* The thought felt warmer than the spring sun flooding my days. I waited for the gift and wrote back, trying to answer more of his questions. Most of our letters were by mail, not e-mail since computer access was only available to him through his workplace.

He wanted to know what inspired me to write these books and questioned me further about ghost towns and the Wild West. I'm sure that this culture seemed as foreign and intriguing to him as Russia did to me. I told him what had inspired the newest book—how I had accidentally stumbled into a ghost town in California and knew I had found a story when I saw the grave of an eleven-year-old girl and read the legend of the words written in her diary. I shared more about the first book series I had written during my years as a stay-at-home mom when I raised my family. Exchanging these details gave us a greater understanding of each other and our cultures.

Yet our backgrounds were so different. How could growing up in his communist culture resemble my world? How could he comprehend the *Fabulous Fifties* where so many of us new brides with aprons and freshly baked pies believed that our handsome Princes would take care of us and our children forever? Valentin Gudkov was barely out of puberty and probably joining the communist party when countless housewives like myself began to fall off our white horses. It didn't take long for some of us to get up, take off our aprons, and face the truth. Apple pies and dreams weren't always going to hold our marriages together. The Russian revolution and the Fairytale Fifties were hardly compatible. Nikita Khrushchev and June Cleaver weren't likely going to be raising a toast anytime soon.

Then I noticed something else from his letter. A clue, perhaps? *Mom returned to the country to finish agricultural*

*season and in two or three weeks she will be home and I will eat normally.*

I drew a deep breath and exhaled slowly. *Don't Russian men cook?* I decided to bury the ugly thought and focus on the photograph of his handsome profile as he sat in the orchard with his grandson.

It was nearly Easter when the package arrived: a small hand-painted wooden egg and a beautiful card.

*12 May, 1998*

*Hello Jan. How are you? I am fine. I am enjoying your e-mail notes and that you liked my photos and the wooden piece. It is Russian Easter egg. The initials "XB (Russian letters) equal to "CR" mean "Christ Resuscitates." It is from the Bible. It is the Russian beautiful tradition to present such eggs during Easter with kiss. I am not very religious person, but I believe in God the creator of nature, people, love, everything outside and inside us. I love Him and feel that He love and help me. Spring begins over here but the weather is cold. It is raining. The sky is very gloomy. I was in my yacht club on weekend and did some fixing job on the boat. Then my crew and I celebrated the beginning of the sailing season and the victory in the Second World War. I will try to send you an e-mail message every week. I look forward to letters and e-mails from you.*

I still treasure that little egg and think of that beautiful Russian tradition, remembering how I wished he could have presented it to me with a kiss. Even then on the deepest level, I hoped that this same God was bringing us together. My skies weren't gloomy as I thought about his words and pictured him with the crew celebrating the beginning of the sailing season. *I am not very religious person, but I believe in God the creator of nature, people, love, everything outside and inside us. I love Him and feel that He love and help me.* Not religious, but deeply spiritual. My hands and heart trembled as I held that little wooden egg in my hand. *Christ Resuscitates.*

Wow.

*21 May, 1998*

    *Hello Jan. Thanks so much for your short e-mail message. I am very glad that you share my thoughts. The weather is cold yet. I was in the country during last weekend and did a lot of job in the garden. In spite of the coldness, all my spring flowers (tulips, narcissuses) have been in full bloom. My mom and grandson, Vadim stayed in the village and will live over there till September. Now I live alone in my flat and do all work as a housekeeper and cook but at the same time, have peace. I am a member of the sailing club of the tractor plant. The sailing yacht "Ariel" is owned by this company and many guys in crew are working in the plant, but not me. As a rule, we take part in some races in the Baltic Sea during the summer months. Welcome to St. Petersburg. I am looking forward to hearing from you. Take care, be happy.*

    Thoughts of watching this man and the Russian crew racing the *Ariel* against the setting sun in the Baltic Sea beat the heck out of a neighborhood association board meeting. My only experience on the Baltic Sea had been on a cruise ship with a friend a few years before, and our visit to St. Petersburg gave me a brief glimpse of a rich culture yet to be discovered. Was there a chance that I might return to this intriguing land that had always fascinated me? What might it be like, visiting his city, his flat, his dacha? I felt drawn like a moth to shimmering northern lights, ignoring the nudges or outright warnings that this man's only interest in me was to get over to the United States and get his green card. Well-meaning friends or family simply did not understand. They weren't reading our letters, feeling our feelings, dreaming our dreams.

    His words returned. *Now I live alone in my flat and do all work as a housekeeper and cook but at the same time, have peace.* No one understood that this was a good man who plants his garden and cleans his flat and (thank you, God) cooks his food. *I like this, Valentin Gudkov. I like you.*

*3 June, 1998*

*Hello Jan. Thank you for the e-mail. I have not gotten your letter yet. Ten days ago on the weekend I did a big job with my car and was very tired. But I relaxed in the evening when I listened to "The Fantastic Symphony" by Berlioz in the concert hall and dreamed about our future meeting.*

*Last weekend I visited my mom and grandson in the country and did some job in the garden. I walked with Vadim and he asked me so many questions about everything that I was overwhelmed. You have so many grandchildren and must have a storm of questions from them. It's very hard and wonderful, isn't it!*

*What are your plans for summer season? Don't be afraid of Russia. Welcome to our city. I'll show you not only the magnificence of it, but the reality of our life. I'll be in the city except 20 days in July. I travel by sails to Stockholm (16-20 of July) and Mariehamn—the main city on the Aland Islands in Finland (23-26 of July). I won't have access to the Internet. It's a pity. I take interest in your books a lot. It does not matter that we are from different cultures; we are both the persons of one Nature, one World. I like to communicate with you. Thank you for your pleasant notes. I hope to hear from you soon. Take care.*

*Val*

His words caught my heart and somehow I knew nothing would ever be the same again. *Valentin, what do you mean you'll show me not only the magnificence of your Russia, but the reality of your life? What do you mean?* My deepest self throbbed with possibility.

My summer season? Plans? I planned to take my dog on some short trips—visit the mountains, the sea—visit a few friends and my family. The Baltic Sea—St. Petersburg? *Dear God in heaven . . .*

Through our correspondence I began to learn more about this intriguing man who loved nature and gardening, his grandson, the arts. St. Petersburg was a beautiful city, but during my brief visit there, I'd never visited more than a few museums, palaces and cathedrals.

11

*Don't be afraid of Russia. Welcome to our city. I'll show you not only the magnificence of it, but the reality of our life.* The lump in my throat settled in the pit of my stomach. I wasn't afraid of Russia, just uncertain about the man who lived there and was now inviting me to share some of it with him.

I questioned Irina further, wanting to learn more about Valentin and gather more details about how Fate brought us together through their chance meeting in Russia. "Irina, tell me more about Valentin," I said carefully one day over a cup of tea. Did she know how many dreams lingered on the edge of my secret horizon?

Irina only knew him as a university friend, but shared as much as she knew. "On this last trip to St. Petersburg, I wasn't going to connect with my friends, including Valentin, because my visit was short and I wanted more time with my son," Irina explained. "When I arrived, I decided to cover the phone with a pillow so as not to be disturbed. I accidentally uncovered the phone one day and it rang. It was Valentin. He knew I had moved to the United States and married, but he took a chance and called my son's flat because he felt he must locate me and tell me about a dream that would not leave his mind. He was shocked that I was in St. Petersburg and told me it was important to speak with me. This surprised me because we were not close friends. But I agreed and decided to include several other University and village friends and make it an evening and dinner together. The evening of our gathering, Valentin drew me aside and told me about his dream," Irina went on.

"I was walking beside the water and across the water someone was coming toward me in a great mist—as a fog upon the sea," Valentin told her. "The hair was long and blowing as in a wind. I was pulled toward this person and knew I must reach this. The dream returned and would not leave my mind. Again and again, I heard inside myself a quiet voice that I must contact you, Irina. Why? I didn't know. Yet I didn't know how. I knew you were somewhere in the United States but I didn't know where you had gone. I took the chance to find your son in your flat and

call him. I could not believe it when you answered the phone!"

Irina seemed as surprised as he. "I didn't know what to say to him," she told me. "Then later that evening around the table, Valentin saw your photograph. He felt drawn to you and asked me if he might write you."

*Destiny. Fate. God?* The questions wrapped themselves around my heart and I could scarcely speak.

Irina explained that she wanted to share this with me because she wondered if somehow it was important for me to know.

*Important? Oh, yes. Yes . . .*

*10 June, 1998*

*Hello Jan. Thanks for your e-mail and your opinion about my English. I began to study English at school when I was ten years old, then I continued in the University and at the language school. But now my English speaking skills are getting rusty and I hope to improve it in future. To my mind I'll never receive your letter because of our Russian mail. It usually takes three weeks to reach St. Petersburg, but sometimes letters disappear. You can send it as a registered mail. It will be much safer. Or better you come to me as soon as possible. It will be much faster than Russian mail. Don't scare about your Russian language. I'll be with you. I have a limited vacation time—four weeks per year and only a fortnight is necessary for the race to Sweden and Finland. As a rule I attend the concert performance once a month. My favorite is the Philharmonic Hall and usually I attend the symphony there. Soon it will be the festival of American music. It's very interesting for me. All my life I live in the big city, but only in the country or small town I relax. Nature is really the best thing in the world! You talk of our ages and I share your thoughts. The most important way is how we want to feel our ages and it does not matter how old we are! I am sure the Father love us and not care. A pity that we should care!*

*Take Care, Jan. Be healthy. Yours Sincerely, Val*

Age. *A pity that we should care,* but okay, I did. He was 52 and I was 61. Nine years my junior. Maybe I should have mailed him photos of the way I looked when I crawled out of bed in the morning, but of course I didn't since I didn't want to scare him to death before we even got a chance to know each other better. Yes, one small fly in the borscht, one black shadow lurking over the white nights. Still, I remembered his words: *The most important way is how we want to feel our ages and it does not matter how old we are! I am sure the Father love us and not care.*

His spiritual insight amazed me, but it wasn't God I was thinking about. The Creator of the Universe actually set up this weird aging thing and I knew He loved me until the end of time. This wasn't the issue. Would the age difference matter to this broad-shouldered, firm-bodied Russian man who didn't look like he had a gray hair on his head? I stared at my aging body in the mirror and wondered if my sparkling personality would blind him forever. I had to trust my deepest self and know that although this might be one of my greatest tests, I could do it. I was a strong woman.

Which also introduced another issue; do Russian men like strong women? I grabbed a magazine I had begun to read about Russian-American relationships and discovered that—yes, Russian men are intrigued by energetic and independent American working wives. *Excellent.* I was still writing books for young readers, consulting and giving seminars and school presentations as well as teaching writing. This was one obstacle to knock off the list. But, I was jumping the gun of course. Good grief, we hadn't even met. By now, however, my strong, independent, mushy self knew we were going to meet. And soon, I hoped.

His words resonated in my brain and my heart: . . . *better you come to me as soon as possible. It will be much faster than Russian mail.*

This was getting too sweet for letters and e-mail.

*19 June, 1998*

*Dear Jan, Thank you for your response and sorry for our mail service. I'm fine and have been in the village for three days. The weather was very hot with a great thunder-*

14

*storm and a number of mosquitoes. You asked some things about me and my life. I was married twice and from these marriages I have two daughters and one grandson.*

*These are my love stories. I've lived single over twelve years very quietly and without big problems. I know this single life is unnatural and want to meet a real, honest friend. I hope God give me a chance. I've seen your photo and I've been receiving your pleasant notes.*

I learned more and more about Valentin's marriages and his life through his letters. Although his two marriages didn't work out, his daughters and grandson were important, and clearly he remained involved in their lives.

I wanted to meet them and I wanted to meet their father.

*Valentin,* I wrote one day when the sun was warm and my pen felt steady and sure against the paper, *can you come to the United States and visit me?*

His response was swift and sent my hopes soaring.

*Thank you for invitation to visit you. I eager to come today, but really, it can be only in spring because of difficulties with visa and earning the money to do this. But yes, I can come. I'm sure everything will happen for this. Please write more about yourself and your marriage.*

I leaned back in my chair and drew a long, slow breath, gripping my pen. I began to share some of my own story because he had asked. *But, where do I begin?* I wondered, my mind backing up to my thirty-year marriage. My pen held steady, but my eyes filled at the return of the memories. How could a simple letter explain what happened? How could I tell Valentin about the broken trust, about how the dishonesty and betrayal gradually began to invade my reality and throw me against cruel rocks. *Everyone thought we were the perfect family,* I wrote him, *but we weren't. I worked and prayed and believed things would change, but they never did. We tried counseling, but we couldn't make it, Valentin,* I said. *Thirty years and it was over, yet in spite of the tears and sadness, the children made everything worth it.*

15

I told him about our three children and how important they were and why I stayed in the marriage as long as I did. Although it wasn't easy, I never regretted that decision. I shared the good things that happened and some of the things that weren't so good. *Valentin, there were days and months when I felt as though it would be easier to give up, especially after Lisa died.* I told him about my firstborn twin daughter and how devastating it was to lose her with cerebral meningitis. *There are some things in life one never understands until you place a child in the ground.*

Still, I realized I was more fortunate than so many because I had her identical twin sister to hold and love. Not long after that, we had another daughter and a son and although raising them was the busiest, craziest time in my life, it was the most rewarding. I told Val about the children's successes, and mine, too. Getting five books picked up by a major publisher wasn't too shabby for the stay-at-home mom. Half the fun was that my children became characters in these books, and we enjoyed the small-town fragments of success and notoriety together. I also mentioned that I had lost a lot of my hearing due to a virus, and although it was a wrenching challenge for me and for those close to me, I refused to let it stop me from living my life to the fullest.

I talked more about my family and mailed him some family photos, some of my grandmother's poetry and a few samples of my father's scenic photography. By this time I knew he had accepted my invitation to visit me. The thought warmed me, and at the same time scared me to death.

*25 June, 1998*

*Hello Dear Jan.*

*I received your letter on Monday after a weekend in the sea. The weather was cold and very gloomy, but even though it was raining, I appreciated my rest. I like to rest near water; it doesn't matter what it is (sea, lake, river). Your marriage story is very sad. You are a strong person. It's a feat (to my mind) to keep marriage only for keeping*

*children intact. I couldn't have done so, I don't think. God and your kids must love you a lot. Maybe our connection is His gift for us. Yes, we have our struggles. The loss of your hearing is not the worst thing in the life. Many people are losing their moral qualities. It is worse. Four years ago I was performed a surgery for ulcers. Doctors cut out two-thirds of my stomach. I am a physically active man and did a lot of hard exercises after the surgery, and now with the help of God I am the healthiest person and I say this every morning! I also suffer from gingivitis (losing some of my teeth) but I'm not a teenager and some things I must lose. But with the years I find more than I lose. My years are my fortune. In my opinion, nothing can spoil a real friendship and love. The fragments of the poems you sent are wonderful and wise. Thank you. I hope to receive your letter soon. I hug you.*

*I hug you.* I felt a gentle current ripple down to the very tips of my bare feet as I sat on my patio reading his letter. *Nothing can spoil a real friendship and love. . . . some things I must lose. But with the years I find more than I lose. My years are my fortune.* I drew a deep breath and smiled. My little Shetland sheepdog nudged me, wanting another walk down the back woodsy trail near my house. Cider didn't understand that what was happening to me might affect her, too.

This warm, fuzzy ball of energy came into my life shortly after my marriage had ended, loving me unconditionally as I struggled to carve out a new life on my own. Was there a possibility that someone on the other side of the world might interrupt our little rituals? I smiled and got her leash, doing the thing we did day after day, year after year.

I didn't know how interrupted things were going to get.

*June 28, 1998*

*Dear Jan, hello. At last I received your letter on return from village. I read everything attentively and admire you for helping your father with his photography. Your father is a wonderful person. Not me. (I have some demerits. Too*

*demanding with Mom and my kids, etc.) I like your father's
life. I hope to meet him. You drive so much. Be careful. My
road to Mom in the village is three hours each way. I don't
drive in the city every day because of the very hard traffic
and bad roads, but I drive in the country with pleasure. On
weekend our crew and I will prepare the boat for a voyage
and competitions. Our yacht club is located in the suburb of
St. Petersburg on the Finnish Gulf coast near Petergof (the
place of fountains).*

*Your father's photography is magnificent, your family
pictures are charming and you are pretty.*

*With hugs, yours sincerely, Val*

*PS If it is comfortable for you, I will call you from
Sweden on 16-20 of July.*

Calling me from Sweden was not just comfortable, it
was wonderful. I felt his energy; his amazing self across
the ocean, across the wires. I felt the hug. It wrapped me
up and held me. His words about his demerits—being too
demanding with his mom and kids—simply sank like
rocks in the Finnish Gulf. What would his *demerits* (I
loved this clever expression!) have to do with our
relationship? We all have our faults.

I told him more about my family, including my
parents who remained active well into their 90's. They
divorced when I was twelve and never remarried. After
Dad retired as a school principal, he built another life in
the magnificent Columbia River Gorge countryside on five
acres near BZ Corner along the little White Salmon River,
finishing out the next 45 years in retirement traveling and
pursuing his first love; photography. His life story,
including his spectacular images of the Navajo people
taken in the 1940's, was featured in a major magazine.
Mom, a gifted violinist, carved out her own niche in the
town where I grew up, teaching music in the public
schools and remaining active in the musical community.

*July 13, 1998 (a card from Finland)*

*Dear Jan. Hello from the sea. Our crew is in the Finnish Gulf near the most beautiful island, one-fourth way to Sweden. Thank you for the letter and nice pictures. You are very happy to have such a big and fine family. I don't have brothers and sisters, only cousins. My father was a physical education teacher in the college for 27 years. He lived with my mother for 45 years and passed away in 1990 after the third heart attack. He was only 68 years old. Since that time I've lived with Mom. In my childhood I spent much time with my grandparents (from mother's side). My grandfather was a construction manager and the dearest person too, very honest man. I'm grateful to him a lot. My mother was a bookkeeper, now she is healthy, active and live for her granddaughter and Vadim. Her name is Nadia. I'm finishing and go to watch. I'll try to write you from Sweden, too. Best wishes to your family. I hug you.*

I felt the hug. Again. The phone call from Finland came at 3: 00 a.m. on the morning of July 17th. His day was my night. I knew we'd get the time zones and schedules figured out. I also knew the status quo might be taking on some change, but I didn't know that it (the status quo) was going to hit the fan and catapult me into a wild Russian dance.

We are not talking about Swan Lake.

*August 8, 1998*

*Hello Dear Jan. I've been in the country for six days making plenty of work in the cabin and garden. It was a big gladness to receive your express mails at once. Thank you for your letters, beautiful cards, and HEART which I hang near my bed.*

*I've missed the biggest part of the first American Music Festival. I've listened only one concert before my departure—some jazz and classics by the philharmonic orchestra. The vacation was good.*

*My present job is for a company that designs and manufactures PC boards for TV and telephone sets. This business became very hard. There are not enough cus-*

*tomers now in Russia. Before this, for first ten years I was
with the Research Institute as a physicist, connecting with
the spectrum, photometric and photographic analysis elec-
tron beams. Then I became an administrator—the deputy
manager of our department. My colleague and I wrote
several scientific reports. That was my only experience with
writing and publishing.*

*This weekend I stay at home. I have decided to clean
the flat, to wash and cook. I like to do housework if I have
free time. I would help you in your garden and garage job, if
I was near you. And yet, I hope I'll help you soon. God will
give us a chance—a gift for me. I'm eager for this. The
laundry is over, I have cooked a mushroom soup and a pork
with vegetables. It will be my food for two or three days.*

*Tomorrow will be the day for church and repairing the
car. My grandfathers didn't believe in God, grandmothers
did. Mom didn't and Dad did for these last twenty years.
He liked to visit churches and often took me. I enjoyed
church ceremony and inside decoration, but I wasn't
interested in religious problems. Nine years ago I embraced
Christianity (the Orthodox Church).*

I continued to learn more and more about this man,
knowing that I could sure use some help in my garden
and garage and I wouldn't mind tasting that mushroom
soup, either. I felt the strong spiritual connections as well.
More spiritual than religious, it appeared we both found
our life-source in the same God who spanned oceans and
denominations and labels. It didn't matter which church
we attended, just that we could breathe the spiritual
truth, searching and embracing life—maybe together?

*August 9, 1998*

*I have been in the church and done the job in the
garage. Everything is okay. I'm so grateful to Irina and to
Chance, when I met her. She showed me your photo and I
wrote to you. For some years Irina was a summer friend of
Mom in the village. After this I met sometimes with her and
her family. I know her not very well, but I thankful to her
once more.*

*I close for now. I wish you good trips to Dad and Nevada. Take care about yourself. Don't be scared to get fat, you are so slim. I want to gain some weight, but it's very difficult for me, I'm so active (one of my demerits).*

*Thank you for your being. I hug you many times.*

The hugs are melting me. I can almost feel the crackling warmth of the fire in his country house drawing me. Will Russian wolves be howling on the hills beyond as we lift our glasses of cider or red wine and raise a toast together? The new possibilities continue to dislodge the status quo in my predictable life.

*I'm so active . . .* he wrote, *one of my demerits.* I smiled silently at this totally irrelevant issue. We are so fortunate to be active and healthy. A Gift!

*September 1, 1998*

*Hello Dear Jan. Thank you for your e-mail and call. I feel very warm after them and they mean to me very, very much. I received your postcard with your father's photograph of magnificent Mt. Shuksan. I'm very glad you have reached your quiet harbour and will be closer to me by e-mail. I have missed you and our connection. I'm looking forward to your messages and letter. We have a lot of problems here in my country. I'm working hard to make living and I'm sure God help me. Take care, be joyful. I'm with you. I hug you a lot. Val*

*PS Your messages mean to me too much. Sun shines brighter after them. Thank you.*

Since the collapse of the Soviet system, I knew that life had become difficult for so many Russians, but now it began to touch me in a personal way as we made our connections and plans for his visit. Would this trip be a financial sacrifice for him? And what about his mother? How did she feel about us? He, like so many other Russians, was now taking any job that became available, and I wondered if his decision to have her come and live with him was more than family closeness but also a

21

financial necessity. I admired him so much and wondered if I could have done the same.

Both of my parents are living and both live in opposite ends of the state, which suits them best. They were divorced in the late 1940s and built strong, productive lives independent of each other. Life was better for all of us after that. Lately however, my 94-year-old father needs me more and more to help him with his photography and his life. He doesn't eat the way he should, his housework and laundry back up, and he still gets stuck under barbed-wire fences trying to get that perfect shot. The three-hour trips to his little house in south central Washington leaves me on the road more than I'd like, but Dad needs those home-cooked dinners for his freezer and sometimes just someone to be there for him. I want his final years to be as rich as they can be and I'm so glad I can help make that possible.

*But with the years I find more than I lose. My years are my fortune.* Valentin's words resonate in the deepest place inside of me. So many times I've been there for others (my choice and without regrets), but now I'm wondering if these coming years will surprise me and become my fortune as well.

# CHAPTER TWO
The Morning of Love

*Serene, I fold my hands and wait,*
*Nor care for wind nor tide nor sea;*
*I rave no more 'gainst time or fate,*
*For, lo! My own shall come to me.*
—*WAITING* ~ John Burroughs (1837-1921)

*6 September, 1998*

*The celebration was pleasant. I had a walk in the forest, then made a pork shish kebob, ate and drank a little near the bonfire in the garden. The night was cold, there was the first early frost. In the morning the water froze with some ice in the small barrel outside the cabin. Now I am home in our quiet flat.*

*After such parties I enjoy my peace and quiet as you. Today I am getting the suntan in the park near my house. Maybe these are the last warm days here. Usually the weather in St. Petersburg is not cold through the first week of October. I am lying under a birch, the leaves are rustling, the sky is blue, the peace is in my heart because I know that you are being and enjoy your peace and quiet not far from me. We both have the same sky, sun and God. Even though there are many problems, I'm sure God help me to meet you.*

Once again his letter resonated somewhere deep in the center of me. Never had someone touched me with words and spirit as this man was touching me. *Connection.* Is that what was happening? I pondered his words. . . . *the peace is in my heart because I know that you are being and enjoy your peace and quiet not far from me. We both have the same sky, sun and God. Even though*

*there are many problems, I'm sure God help me to meet you.*

I held the letter close. This ex-communist had a spiritual depth that resonated in my soul. He continued to apologize for his poor English, yet I saw beauty and skill as he carved words from his heart. It was as though he was in the village under the same sky and sun and God, carving something of worth from a simple scrap of wood. I didn't have the words to express how I felt during these early days of our correspondence, but I tried. Our letters, phone calls and e-mails continued.

*It does not matter that we are from different cultures,* he wrote, *we are both the persons of one Nature, one World.* Would the differences in our culture, religion, family backgrounds matter when the most important issues of the heart were emerging?

*We can do this, Valentin Gudkov. I know we can.*

I continued to read everything I could get my hands on, especially the books and articles on the Russian-American relationships. In *Wedded Strangers, The Challenges of Russian-American Relationships,* author Lynn Visson asks the question: "Why are these Americans and Russians so intensely attracted to each other? What do they expect from romance and marriage? For better or for worse, how do they live together? . . . The ups and downs in the relationship between the Russian and American partners often mirror the relationship between their countries."1 "Differences in roles and expectations, common enough between spouses of the same culture, can become major sources of conflict when the couple comes from very different backgrounds."2

*Why are these Americans and Russians so intensely attracted to each other?* Why, indeed!

I thought about the author's words, her warnings. It made no sense that the differences between our countries and the cultural disparity would affect our relationship. The connection with this man had already begun to influence me profoundly and these warnings and grim statistics felt like thorns in my garden, bitter spices in my soup. I brushed her words aside. Glasnost and perestroika tasted sweet on my tongue as I dreamed about white

nights with a blue-eyed Russian man beside me; white nights when twilight lingers in the northern skies.

So what was the problem? Was this Harvard-educated woman who had married a Russian man overstating the issues just a bit? If our friendship grew into something more, certainly none of these conflicts would be ours. Valentin didn't even slightly resemble the Russian men profiled in her book, and of course, I didn't resemble those American woman who married them! In spite of normal problems we would undoubtedly face, we weren't going to mirror these dysfunctional couples in the least. Still I couldn't put the book down. Well written. Fascinating. Entertaining.

*9 September, 1998*

*Tomorrow I am going to meet with Irina's daughter and give her the letter and a small gift to you, Jan, Dear! I send you a tiny wooden bowl with tender hugs and an egg with kiss. I hope to do this action myself soon. I eager to do it now, but I haven't got enough possibilities yet. It's a pity.*

*I received your postcard from Bodie two hours ago. Thank you! I feel very warm when I'm reading your words and do it usually before going to bed under your "heart" which is hanging close to my bed. It relaxes me and I dream about you. I look forward to your e-mails. They help me a lot. I want to know the day of your birth and congratulate you in time. Take care of yourself. I want to see you smiling.*

*With hugs, Val*

I waited for the tiny wooden bowl and the egg. While I waited, I dreamed about him, too and wondered what that kiss might feel like. It was, for me, the morning of love, the sweetest of days. Bathed in a comforting surge of feelings I'd thought had been lost in the gray trail behind me, I felt renewed and re-energized. I shared more about myself, including my new venture writing ghost town mysteries for young readers. I had sent him a postcard from Bodie, California, once known as the wildest mining camp in the West. Bodie became the setting for my first ghost town

mystery and on that particular occasion, I had been invited back to do an author signing for the *Friends of Bodie* celebration at the Bodie State Historic Park museum. "Exploring old ghost towns and dredging up story ideas is exciting," I wrote, "but most of the time I stay home and write, or go into schools and give young author presentations. I love connecting with kids and since I still have to make a living, what better way to do it?"

I also sent him more photographs of myself—one a shamelessly flattering publicity shot of Calamity Jan in my western hat. I waited expectantly for that tiny wooden bowl, but even more for those tender hugs and that kiss. "Valentin Gudkov, your Russian Easter traditions are quite wonderful." *And you are, too . . .*

*15 September, 1998*

*Thank you for your very warm letters and photos. You are so pretty! I want to be with you more and more, to share happiness and troubles with you. I feel trembling inside me as in youth and hear whispering that I mustn't lose you. I'm sure we will be good partners, real friends and more. I'll try to do everything for this and the Father help me. I'm eager to come as soon as possible! Take care about yourself, please! You travel to help your dad so much. Old age is inevitable thing, but, in spite of diseases, it's the time of peace, quiet and thinking.*

*Last week till today was warm and sunny. Today became cooler, it's raining. Fall begins. There are a lot of yellow leaves yet, and many of them are falling.*

I walked down my woods trail with Cider, hugging his words close. My little sheltie tugged at her leash as this same trembling and whispering tugged at my heart. *I will be 61 years-old tomorrow, and I am a girl again. How am I ever going to explain this to my three children?*

*16 September, 1998* (My birthday)

*Such a wonderful day! With your warm heart I wish you many, many years of happiness in all seasons of*

*LOVE. Thank your parents for your appearance in this wonderful world. I wish them many years of being. Be healthy. I'm praying for this every morning. God give me a gift of your being. I hug you strongly and tenderly.*

*I've returned from sauna. We, my two friends since University years, and I, usually go to the sauna near my house every week after working day. It's a fine way to relax and connect, a charge of cheerfulness for a whole week. Today I was alone and I have two quiet hours for dreaming about future. Now I'm taking supper and drinking a little for you, your parents and the Magic. I look forward to hear from you and know many fragments of your real life. My family, Goudkov, is in French. In English it's Goodkov or Gudkov.*

This connection. It was Magic. Something so deep was happening inside of me. I wrote him a long e-mail, sharing more of my heart and dreams, hoping he could feel my feelings. "I feel your strong and tender hug, Val," I wrote, "and that is simply amazing right now. It's windy and gray outside, but inside—my heart is as warm and bright as the fire in my fireplace."

*21 September, 1998*

*Hello Jan! Thank you for so warm e-mail. I have mailed you the letter on 17ᵗʰ of September through Finland because it will reach you faster than Russian mail. To my mind I've responded to some of your questions and look forward to get many others. My heart is full of our connection. Take care of yourself. Thank you for existing. I hug and kiss you with love.*

*With love . . .*

*Love?* Did he mean that? Did he really, *really* mean that? His letters, his words were taking hold in the deepest place inside of me. Yet, can people fall in love when they haven't even met? How can these feelings and a sense of true inner reality become so strong when our letters and phone calls are making the connections? *Love and falling in love can't just happen like this, can it?* Every-

27

thing inside me screamed against the sensible voice telling me that this was totally crazy. Nuts. Only fools believe they are falling in love without physically meeting and knowing a person. Yet it was happening to me.

*But how?*

How real and authentic are these connections that reach beyond the physical realm? My own life experiences had taught me that life's truest realities do stretch beyond our five senses—in the unseen world of Spirit. Most of us know this and yet, when Love and Spirit move into our physically defined world, we're not always sure how to fit it into the familiar framework of our five senses.

St. Augustine said, "Our whole business therefore in this life is to restore to health the eye of the heart whereby God may be seen." And God is Love.

And Love was happening to me.

*Love is happening to me.*

*28 September, 1998*

*My dearest Jan, hello. Something is happening with me. I didn't write you for seven days and now I feel the shortage of our connection—the defect of the last week. I miss and need you and thank God for your being. I got the new traveling passport on Friday. The first step to you is over. I'm glad. The second step is the visa to the United States Thank you for sending everything I will need to accomplish this. How is your rest on the small lake? Mom greet you. Take care about yourself. I hug you very tender. Val*

I tried to take a relaxing break with the children and grandchildren, but how do I do that when a Russian man is about to turn my life upside down? Can my kids sense something is happening? I think my dog does.

*2 October, 1998*

*Good morning my Dearest Jan. Thank you for your pleasant letter, congratulation card and your Heart. I am sure the Miracle is nearly here. I am ready and feel that we will become two inseparable parts of the Whole. I want to*

*be near you forever. It seems very strange, but I am really sure that it will be so. You are my Gift. Even Mom told me "Don't be a fool. It's your fate." She and Katia, too, want to see us together. I am grateful to them for this.*

*It's cold here. We have central heating for the whole city, but it has not been turned on yet. I use the blanket and the goose down comforter at the same time, but you are warming me during nights. I hug you with tender love. Please write me as often as you can. It's a light in our dark reality. Val*

*. . . two inseparable parts of the Whole . . . Our fate . . .* The excitement and realities creep closer and warm me as I ponder a new life with this man. Snuggling up in my goose down comforter doesn't totally banish a few discomforting thoughts sneaking in like aliens, though. Why won't the city of St. Petersburg turn on the heat sooner? This is October! Why must the people wait for the city to decide when they will be warm?

Okay. If this really should work out for us, then we'd just live in the United States and only visit Russia during the warmer summer months. I hoped he liked my plan. When he spoke of my letters—and of me—being a light in his dark reality, I knew the dark reality meant the life in Russia. To date, I had eleven grandchildren. How could I leave all of them and move to a place that didn't even let the city dwellers have heat until late October or early November? Wouldn't it make more sense for him to move here than for me to move there? *Oh, Valentin, I'm not scared; this is just so different for me.*

5 October, 1998

*Jan. Your e-mails and letters make my days full of hard work, not a little bit nicer, but wonderful. Thank you. I have given your books to Dasha. Mom has begun to work in a teenage club. Katie is studying in Moscow and has two years before graduation and then she will be a doctor. Vadim is going to day-care.*

"Oh, Val," I wrote back that night as I sat in my chair by the crackling fire. "I hope Dasha enjoys the book. Your

29

children and grandson must be very special. I can't wait to meet them. And you." *What will it be like when I see you for the first time?* I wondered, setting down the pen and paper and wrapping my lap robe around me. I waited and wondered as the fire burned low and my dreams settled down for the night.

*7 October, 1998* (Val's 52nd birthday)

*My first free day after ten days of heavy work. It's a wonderful sunny morning, the first fall's frost. I've done my morning exercises and taken your mail gift from the post box. Thank you, my Honey.*
*5:20 p.m.*
*Mom and I (and you) are celebrating my appearance. (It was at 8 o'clock in the morning many years ago.) The card is perfect. I'm fine because the Girl is sitting cheek-to-cheek with the Boy. I have the feeling of something beautiful ahead. Now I know God, as my real friend, give me the pretty girl and I'm sure we will be together. You are my Destiny. I'll give you the happiness. Darling Jan, you have called me and given me one more gift! It's great to hear your voice and feel you through the ocean. Sorry for my poor Russian English. I hope you will be patient and I'll be diligent pupil. I'm clinging to you tenderly.*

My heart could have burst with the power and beauty of all he was saying and feeling because I was feeling it, too. *Darling Jan. You are my Destiny. I'll give you the happiness.* I blushed often and wondered if my friends and family thought I was having hot flashes due to delayed menopause. This Russian-American romance was moving faster than the Trans-Siberian Railway.

*10 October, 1998*

*My Sweetie, Hello! I'm in the country. Mom has stayed at home. It's the last visit here this year. I got up at 5 o'clock in the morning, left home at 7 (an hour and a half before the dawn) and arrived to the village at 10. It was raining all the day. I pruned some trees, gathered leaves, covered the trunks of the young apple trees with fir*

*branches to prevent them from hares, stored all tools. I've done a lot of work. Now, I'm relaxing after the supper. It's very quiet here, only barkling of dogs and noise of rain. It's a pity that the girl is so far, though. I feel her very close and tender and my arms are around her. I'm falling asleep hugging you.*

*11 October, 1998.*

*I arrived back to flat six hours ago. I've gotten enough sleeping last night. I like to sleep inside wooden house of village. I've closed it now for winter. The garden season is over, one more year passed away. The weather was very gloomy, the sky was grey and very low, it was raining. The nature was crying! I like fall for different colors of plants, for fresh special air, but I dislike such dark days as this weekend and I'm waiting for the winter. I'm thinking about you, looking to your photo, and go to bed. Good night. Be joyful. I kiss you.*

Good night, Valentin. *I'm feeling that kiss.*

*15 October, 1998*

*Hello my Darling! I've gotten the Express mail. Thank you for your pleasant letter and the invitation. I'll take another step to you on Monday. God help me. I'm sure that we will be sitting near your fireplace in winter. There are a lot of problems, but I'm not confused. Everything will be all right, we will be for each other in wonderful days and in struggles It's not easy to share struggles. Only real friends can do it. I've had many "friends," but only some of them are real. It's hard to be confident, especially in my country, but I'm trying. I pray for our miracle, too. A small miracle has already happened with Mom. She didn't like some of my friends, my dogs, any of my girlfriends and both wives. And from the first glance she liked your photo and said that you are my first real pleasant-pretty woman. It's the miracle! I'm happy.*

Thank you, Mom. Nadia. The smile stays deep as Val and I talk through letters and the e-mail connections,

sharing our lives with each other; sharing our hopes, our dreams.

*18 October, 1998*

*All my life I was very active, healthy and joyful man. I was fond of sports, diving from the board, sailing, alpine ski. For four years I was working in the private firm which had the 40-feet sailing boat for participating in regattas. I was the member of the crew and during summer seasons my job was sailing in Europe. In April 1994 we returned from England; six guys, four yachtsmen, our boss and his friend. In Germany I felt a pain in my stomach, then I was suffering ten days more till we arrived to St. Petersburg. Then hospital. They cut two-thirds of my stomach. I lost 45 lbs of my weight, some teeth and thought that it was the end. God helped me. I worked very hard for recovery and became the healthiest person in two years. And now, I'm the happiest one, too, because I have YOU.*

He had gone through so much, yet had come through it with courage, hard work and faith. Our e-mails, letters and phone calls helped us learn more and more about each other and while our journeys hadn't always been easy, we now found some common ground and shared a deeper understanding. He asked me to share more about my life after my divorce.

"Valentin, the difficult and sometimes lonely years after my 30-year marriage ended were important years because they helped me find the girl-woman who got lost in everyone else's lives," I wrote, explaining how it had been my choice to be a stay-at-home mom. While I never regretted that decision, I didn't realize that this would leave me ill-prepared for the job market and outside world if my well-laid plans (fairytale) crumbled.

And the fairytale crumbled, as so many fairytales do. The frazzled Princess fell off the horse with a thud. Thankfully, my children were already married or on their own when it happened, and the huge bruises on my rear end (and heart) healed in due time.

I didn't know I could face college and menopause at the same time, but I did. I didn't know that after I got my

bachelor's degree I could actually begin my Masters program in psychology and counseling, but I did that, too. I didn't know I'd also be accepted at Hedgebrook, a prestigious writer's program where I'd meet and chat with well-known feminist, Gloria Steinem.

Back in the 1950's, many of us resisted the feminist movement. Gloria and her followers came out of every nook and cranny like fire ants, stirring up controversy as they insisted, for example, that women deserved equal consideration in the home and the workplace. *Why such a fuss?* I wondered then when my life seemed so idyllic and tidy; my dreams as colorful and smooth as a freshly-ironed apron.

Why, indeed!

She was beautiful and gracious and we laughed and talked, and even though I chose not to tell her all the pathetic details, she got the message, because I'm sure she had heard it a thousand times before. She knew that there were so many married women like me who struggled then for such simple things as getting our own checkbooks; women who simply wanted the respect and equality we deserved in our homes or the workplace. She knew and broke ground for us and although I didn't agree with everything on her platform—as I faced her that evening, I realized how far women had come—how far I had come—and I thanked her.

I tried to share all of this with this Russian man—all of these things that were so intrinsically part of a life and culture so different than his. Yet was it so dissimilar? Were male-female, Russian-American issues as far apart as the oceans that separated them?

I would find out. Very soon.

*20 October, 1998*

*My Dearest Jan. The problem with my knee is a trifle. I damaged a knee two years ago skiing in the mountains, they cut the right meniscus a year ago. I had to give up alpine ski, but I still Nordic ski. Now I ought to have a plastic surgery with my right knee cord. Don't worry, it's not a hard surgery and I have a very good doctor. Now you know all my medical problems. In spite of this I feel you*

*very close and need you. The Miracle is near us, and we can do it! Take care about yourself, I'm with you. Best regards to your family. I hug and kiss you tenderly.*

My meniscus were melting just thinking about those tender Russian kisses. Sweet, delicious dreams filled my waking hours and softened my nights.

*23 October, 1998*

*Hello my Dearest Jan. The best help for me now are your feelings and our connection. Please write me as often as you can and sorry for my rare responses. My knee hurts me not all the time, though sometimes the pain is strong. On Monday I'll know the approximate date of the surgery. I want to take it as soon as possible. The consulate took my visa application on Tuesday. The interview (and result) will be in two weeks. You are helping me in day battles a lot. Thank you my Girl. You are with me, I feel it strongly. Take care about yourself. I kiss you tenderly. I miss you.*

I felt a growing concern as he struggled with his pain and faced the surgery, calling him as often as I could. Exchanging letters, cards and e-mails helped us as we moved through this struggle together. "Valentin, be strong. My thoughts and prayers and hugs surround you. Soon we will be together. Hold on to this."

I sent him a poignant card with a boy and a girl together on a beach. They were young (as our spirits were young) and holding hands.

*30 October, 1998*

*Hello my Sweetie. Thank you for all your e-mails and the card of the Boy and the Girl on the beach. This gives me your love and strength. I will be joyful and quiet if you won't walk alone in the woods. Please take care about yourself. I need you safe and happy. I'm with you every moment sitting on the other beach. I miss you a lot Dear Jan.*

I feel him, even though my sunset is his sunrise. *Take care of yourself, Valentin Soon we will be together.*

*1 November, 1998*

*October is over, it was warm for St Petersburg. The trees are standing naked, the beauty of different colors is over too. Jan Dearest, I received your letter yesterday. Thank you so much. I'm very glad that your Dad is hanging on. Best wishes to him. I hope to meet him healthy and joyful. Did you tell him about us? And your children?*

*Our weather is not like yours. Here are cloudy gray low sky, rain and cold. The day has become shorter. The heat is turned on in city now and it's warm in the flat. What will be during fronts? Nobody does know. Don't worry about our food and things, for this I can make money. Present hard job is the temporary necessity. I look forward to being with you by the fire during cold winter nights and drink your famous hot cider with spices. It doesn't matter our ages, our hearts are young. And perfection? What is it? I don't know. Presently it's perfect, tomorrow it's not. Somebody said: "Perfect is the enemy of good." In my opinion, it's right. It's 10:50 now. I'm falling asleep and longing for you.*

I'd already told my three married children that I was corresponding with a Russian man, a friend of my neighbor, Irina. I explained that he was applying for a visa to work with me on a book project with the possibility that my books might be translated and marketed in Russia. I didn't throw in the added detail that I might be falling in love because (1) they were very busy with their own lives and (2) Mom/Grandy/Nana probably isn't supposed to be behaving like this.

I did feel some concern about our age difference, though, and wanted him to understand my feelings about those realities and potential pitfalls as time (aging) marched on. I kept it upbeat but knew I needed to face that one head-on, and I did. I also talked about my past, my family, my traditional value system, my dreams. These days of letters and e-mails were important days and months for both of us.

*4 November, 1998*

*Hello Honey. Thank you so much for your sincere sharing in the letter with Mom's card. It's very important for me. The second small (not small for me) miracle has happened. I'm astonished—so similar we are. For many years my friends (sports, crew, ski) were saying to me that I'm crazy man from the 19th century for my moral values. For me it was normal, for them so foolish. Your strong value system is so close for me that it seems incredible such resemblance, though I'm very, very glad. Now I'm sure You are the One God is sending me. I love you and I want you very strong. Please don't think about your age. It's our treasure and you are mine. Be safe, joyful and so close to me. I hug you tenderly.*

*PS I've got the visa two hours ago. It's valid till October 20th, 1999. Well done!*

He got the visa? "*THE VISA.* Oh, dear God, it's happening!" This news and the reality of his coming made every inch of my flesh tingle. I danced all over the house, trying not to trip over my poor little dog. "He's coming, Cider! The Russian is coming!"

Cider barked, probably because she thought I might be taking her for another walk. I dropped to the floor and hugged her, realizing she felt my excitement. "Even better than a walk, Cider," I said with tears waiting to burst from the deepest place inside of me. But I didn't know how to explain those unshed tears of happiness, I didn't know how to explain that joy of knowing that my life would never be the same.

The business visa would give us four weeks to work on our book project together, allocating a six-month period of time in which to use those weeks. His company would consider publishing my books in Russia, but first Val was to determine if the project was feasible, and if so, to begin the process of translation. I just hoped we could concentrate on the project instead of each other, but suspected we might not. The delicious thought melted me.

*5 November, 1998*

> *Hello my honey girl. I got up at 7 a.m. and looked through the windows. Everything was white outside—the first snow in St. Petersburg. It seems that everything in our world is so pure and innocent. I'm hurrying to you and do everything to draw near the day of our meeting. I wish to be with you forever, because I've never had such feelings as now. The Father tells me that you are (and somebody inside me—I guess, that is He too) my inseparable part in this World and I believe Him. With the visa, one more step to you is over. The Father and you are helping me. I kiss your brown eyes. Good dreams to you.*

The dreams were so good and threaded themselves through my days of anticipation and preparation.

*6 November, 1998*

> *Jan, Darling! My mom and I congratulate your mother with the birthday. Many healthy years and joyful days to her. I'm hurrying to start a lifetime of love, to walk hand-in-hand with you through the years. On Tuesday I'll meet with my doctor to decide about surgery on knee. I'm holding you very close and thinking of you.*

Mom, a retired music teacher, had just turned 88 and continued to be active in her community; playing her violin in the symphony orchestra (which she co-founded), heading up music and scholarship organizations, playing the organ at church and community events, and still driving. She had always been my cheerleader, but when she learned that I had been corresponding with a Russian man and that he was coming to stay with me, she stopped cheering and began to express her concerns.

"Janet, what are you doing?"

I shared portions of his letters which may have assuaged her fears somewhat, but I was still the youngest of her three girls and that was that. "He's amazing, Mom," I assured her. "He loves the symphonies and the opera just like you do, and he sails in yacht competitions all over the world." Her lack of enthusiasm felt worse than a

37

wounded prelude. "He's a friend of my neighbor, and he's just coming to help me with my books."

"He's coming to help you with your books . . ." One eyebrow arched like a sharp, bent knife.

I nodded, feeling a catch in my throat. Her other two daughters and my younger brother were married and living quite normal lives. Although Mom was progressive and independent, when it came to her children (no matter our ages), she was fiercely protective. A Russian ex-communist nine years younger than her daughter introduced the possibility of a not-so-grand finale in her well orchestrated life symphony. She suspected, and with good reason, that our planned book project might be playing second fiddle to a dubious dance.

*8 November, 1998*

*Good morning! I kiss you before you drink your coffee. You are with me every moment. I feel you, but I desire to trade the girl I hugging in thoughts for the girl I hugging really and feeling her natural warmth. It will be soon. I'm hurrying. The day was nice. I'm waiting for my friend, Vladimir. We are going to drive to our yacht club to prepare our ice-boat for the winter season. He is the steersman, I'm the sheetsman in our club. It's a pity that I can't be a real partner for him because of my knee. We will do some job in the club—repairing the hull of the ice-boat and sails. I am waiting for January and looking forward to hearing you soon. I love and miss you so much. Be safe and joyful.*

*10 November, 1998*

*I'm looking for a call of my driver. It'll be a lot of work today. It's very hard to make money (honestly) now. The prices run up and the salary is the same and soon I will lose job because I need surgery on my right knee. It takes 25-40 days hospital and recovering time.*

*8:45 p.m. I have just returned from sauna. It was a good relaxing after a working day. I'm perfect. I'm going to visit you in January-February (if everything is ok) and we will consider the date of your visit. But, I'm sure the girl will*

*keep the boy forever who will agree and will be very patient. The best years are ahead!*

*Forever?* I gripped a chair until my knuckles whitened, knowing exactly what he was saying. "Oh, Valentin—yes, YES, the best years are ahead!"

*13 November, 1998*

*Hello Jan. I'm missing you and our connections a lot. Thank you for the last e-mail. After the revision of my knee, the doctors decided not to do the surgery, but to make a ten days course of therapy in the hospital before Christmas. Be with me. You are giving me so much every moment. You keep my heart very warm.*

*PS Without some risk, our life becomes tasteless. Do a risk, please Jany.*

*Do a risk.* His charming use of language—the way he spoke from his heart felt like a heady rush of warm wind in November. "I will do a risk, Val."
*How could I do otherwise?*
Author Lynn Visson says; "Generally speaking, the couples who embark on these marriages are persuaded that mutual attraction and love will conquer all obstacles. In the last few years more and more Russians and Americans have taken that risk."[3]
"Obstacles?"

*15 November, 1998*

*My Sweetie. I'm so glad to renew our connections after a week of e-mail silence. You have become the irreplaceable part of my life and I am missing you a lot. I feel your love and care very deeply. Thank you so much. It's very important for me. Though the life is not easy here, and I am tired, my soul is quiet because you are warming me every moment.*

*Best wishes to your Dad. I want so much to meet him. I see and feel, so directly, your ride through his countryside, the beauty of colors and magnificent mountains. My father*

*was a great lover of Nature. He passed away returning from the countryside one sunny Saturday eight years ago. He was only 68 years old. Take care of your Dad and God help you. I am helping you through my prayers. The celebrating dinner for Mom's birthday is ended. We drank a little and toasted you and your family, too. Our relatives and her friends congratulated her by phone and she was pleased that they had remembered her in such hard times. Here we visit friends and family more rarely than in the past. It's very sad, but this is our reality.*

I wish I could have shared in the birthday celebration, the toast. I feel a strong kinship with his mom already. The photographs show me she is still a beautiful woman in her mid 70's with silky gray-blonde hair, blue eyes and a charming smile. I especially love the photographs of her in the orchard with her great-grandson, Vadim. Her smile seems wider under the fruit trees in the country house.

*20 November, 1998*

*Hello my Sweetie. Thank you for your long and pleasant e-mail. I'm missing you so much. I plan to buy the ticket in the beginning of January and to be in Seattle at the end of it. Poor Cider will now have someone else to keep the boss warm! I am hurrying to you, my dearest. I congratulate your family and you with Thanksgiving days. I'm hugging you with love.*

It's a good thing my mom isn't reading our letters now. Or my kids. The dog will be fine.

*21 November, 1998*

*My Dear Jan. Good morning! I visited two churches; the Orthodox and the Catholic. I liked both services and put up prayers for us and solution of our challenges of every day. I long for our happiness because it's so rare and life is so short. Let our meeting be as soon as possible!*
*I like home food. I usually live alone for five months in summer season and cook, do everything for one person without great pleasure. And, at the same time, I like to cook*

*for our crew of ten during the races. The guys appreciate my cooking, especially soups. I know that housekeeping (cooking +. . .) is a very hard job if you make it alone. But it becomes a pleasure, with a good partner (or good motivation). Do you agree? I eat not much, but a little and often and have food with me, if I'm outside. I'm not scared and run off not to Siberia but to you! We will be patient and help each other. I love you.*

*I love you.* I gripped the letter tight and felt the warm rush of his words, the promise they held. *Oh, Valentin . . . Valentin . . .* The love wrapped me up and held me close as I curled up in my chair, thinking about his letter. *Life will become sweeter with a good partner—with you my dearest,* he wrote. "Yes. Life will be sweeter now."

*22 November, 1998*

*My Darling. One more day is over. I have begun to cross out days in the calendar. Two months before my departure to you! I agree that February is still cold and barren, but for us it will be Valentine's month and Valentine's life ahead. Take care of yourself, be healthy. I am with you every instant. I kiss you many, many times. I miss you.*

*Valentin. My Valentine.* What is happening to me? I feel a catch in my throat, a nudge at the back edge of my mind. Will he feel this same excitement once we meet? Will I? Soon we're going to be doing a risk, aren't we? Is doing a risk with a Russian something like facing Siberia with a candle?

*Dear God, I hope not.*

*27 November, 1998*

*Hello my Honey! One more week is over; one more step to you is done. You are helping and warming me every minute. Today is the sixth anniversary at work and we are celebrating a little. You are beside me. The Miracle is with us. I thank the Father. You, my sweetie are His Gift to me. I love you. Best wishes to your mom and children. I am sure*

41

*we will become good friends. Say hello to Cider. Keep me
some cider with spices beside cozy fire. I love you.*

Mom—Dad—my children, you're going to love him. If
you don't, it's too late since I already do.

*1 December, 1998*

*Hello my Darling. The fall season has passed and your
letter came at its last day. In spite of cold weather here, it
warms me and gives me your love and care. Thanks for
your wonderful photos. You are so charming and desirable
on the pictures that, I am afraid, what will be in reality! We
have many riches. And money? We will try to make enough
money for living and some more, but not very much. There
are so many more interesting things around us. I have had
many troubles through money. I don't like them. We are still
young and the best years are ahead. We will go through all
struggles together. The Russian boy is ready and in a hurry
to escort the girl with a red rose. And now his eyes are
closing. I hug you tenderly and go to bed. Goodnight, my
Janet.*

"Goodnight, my Valentine." *My heart.*

*4 December, 1998*

*My Sweetie, hello! Your letter with picture came
yesterday and warm and excite me very much. You are so
pretty and feminine. I feel you so close to me. I have never
felt so deeply. I love you.*

His words . . . *I love you* . . . wrapped me up like a
warm blanket. December winds and rain pelted against
my little house and it didn't matter because I knew that
before long I'd probably have this Russian man snuggling
right here with me on the sheepskin rug by the cozy fire. I
stroked my little dog, who slept, oblivious—her head in my
lap, her long sable coat golden by the firelight.

*About my stomach problem. Before 1995 I have never
suffered from it. It was unexpected. The doctors found the*

*ulcer and decided to cut 2/3 of stomach to prevent the possibility of cancer. God help me and now I am well. Thank you for your sincerity and care. We will be open and honest about everything. I hug and kiss you tenderly.*

I felt his tender hug and the kiss and wrote back, feeling the sweetness of him. "Yes, we will be open and honest about everything, dear Valentin." And I meant it. While his health issues troubled me, I knew I could help him eat right and stay healthy since I enjoyed natural foods and simple cooking now. After thirty years of domestic duty, the Kitchen Queen moved from kitchen counter to office computer, happily trading her pastry cloth, rolling pin and cookie cutters, for a new and rewarding life as a writer and writing instructor. I smiled and looked around the small but cozy house I had worked so hard for. After college I began to teach writing, making double house payments so that I could pay off the fifteen-year mortgage in seven years. And I did it. I had accomplished this on my own and now I hoped I could be sharing all of this with him. I smiled to myself, realizing I'd practically married this guy before we'd even met. Good grief. We hadn't even started our book project! *Keep your boots on, Calamity.*

*5 December, 1998*

*I love you, and when does it begin? I don't know. It seems, that I have waited for you all my life. I feel you so deep, though I have never seen you. They say it is incredible for a man, because a man loves by his eyes! It is only the beginning for us, and we should keep our love very tenderly, and we will do this. All storms and winds will be not heavy for us if we are patient and open to each other. Do you agree with me? I'm sure you do! I close and will continue tomorrow. You will be close. Goodnight, Jany.*

Storms and winds?

*6 December, 1998*

*Hi my Sweetie. I returned from the church where I prayed for us and my second trip to the United States. My first trip was a visit with my father's friend who had been living in Los Angeles. He showed me many interesting places in Southern California. Then I visited my university friends in San Jose. I liked my trip, especially the ocean. The second trip will be magnificent, I know.*

*Before the church I listened to the chamber music concert (Shuman, Liszt and Russian romances) in one of our museums. I shared this beautiful music with you, my Darling. I dreamed to be stranded together near the fireplace, to hear monk's singing, to visit your parents and . . . to be one with you. I feel the closeness of you. I kiss you, I need you.*

Oh, my gosh. Lord, keep the monks and my parents (and children and grandchildren) in Siberia or Disneyland for a little while, okay?

*8 December, 1998 9 a.m.*

*I am awaiting the truck and want to share wonderful weather here. The light snowfall began two days ago and it is snowing yet. The white color has covered everything. It seems that our world is so pure and innocent, and I feel the quiet in myself. Yesterday after working hours I was walking through our park-forest. There was enough snow for the first skiing (about 8 inches) and I decided to open the ski season today after the job. It will be a good relaxation for me.*

*8:50 p.m.*

*Honey, hello again. Today I have finished my working day earlier. I bandaged my knee and rushed to the park. It was wonderful—the snow ended, no sound, the temperature was about 25 F, trees were in white clothes, fresh air and silence and only croak of crows. Peace, quiet. I was skiing (very carefully) for an hour. My knee creaked, but didn't hurt me. I'm glad. On Monday I have to enter the hospital for surgery on knee.*

God be with you my dearest. And with me. I needed to clean my house, get the book project ready; get *myself* ready. "I'm thinking of you," I wrote him. "Valentin, please take care of yourself and find peace and healing in the days ahead as you recover from the surgery. I will be close beside you. Can you feel the caring and love I'm sending?"

*11 December, 1998*

*Hello Honey. I'm glad that you are in your cozy quiet house and your father is in good spirits. Soon I can help you in reality. You are healing me from a distance. Last Tuesday I tested my knee by one-hour skiing in our park. The knee creaked, but didn't trouble me. It is the result of your care and my exercises. Thanks. I will be the healthiest person after the hospital therapy and rest. I'm glad Cider is still on the job keeping you warm until I come.*

*Please be careful on the icy roads. It is a hard and dangerous job to drive in such conditions. The last working week has passed. Hurrah! I have made enough money for the ticket, the hospital and some living. The new life is ahead. Thank you my dearest Janet. It's your and God's gift for me. Say hello to your family. Merry Christmas and the Happy New Year! I miss you and kiss you and Love you.*

And I miss you and kiss you and love you, my Christmas Valentine. I am feeling your love, but Cider sleeps on the rug below my bed. She is wonderful and does her job by barking at every noise outside the house, but she is not keeping me warm.

You hold more possibility to accomplish that job.

*12 December, 1998*

*My Darling, hello. Thank you for the e-mails, they are the great help for me. Tomorrow I will see Dasha. We will visit the new exhibition of fine and applied art and graphics in Russian museum. It has the best collection of Russian art and sculpture in the world. And on Monday, one more step to you—the hospital's "resort."*

*Honey, I'm missing you so much. It's a pity that I can present you only the pressed flower leaves. Your leaves are not from the country. For fifteen years I have had seven rose bushes, but three years ago they froze during the cruel winter. Now I'm without roses, but I have the best one—you, my rose girl. Thank God for your being. Be safe, joyful and very careful. I need you. I love you. I'm with you.*

The pressed flower leaves arrived in a card. *Thank God for your being.* My insides melted as I read his words and felt the love. I'd been dating off and on for the last few years, and there wasn't any man around who came close to this Russian. The author of *Wedded Strangers* was getting it right this time. Her description of the Russian man fit like a smooth leather glove right out of Dr. Zhivago; ". . . handsome, romantic, strong and, despite a good dose of male chauvinism, extremely charming."[4]

All well and good, minus the chauvinism, of course. The male chauvinism might be an issue for some, but it wouldn't be for us. It was amazing how much I knew and I hadn't even met him yet!

*15 December, 1998*

*Janet. Your letter reached me on Sunday evening. It gave me so much your love and many wise thoughts. You are right, we both must be sure in our such bright and marvelous feelings. The only way to be sure is to be together—simply live, share everything and present our love to each other. The most parts of our lives have passed, but we are still young and are longing to give all positive experience and spiritual world to each other. It's very important that we want to do this and will be patient. I love you. Hold me, please and I will hold you strong and tenderly. I kiss your brown eyes.*

I'm so busy with the Christmas holidays; the hustle and bustle of grandchildren, visiting my parents, listening to Carols and lighting candles. I'll be trimming a tree and hanging a wreath, but not hanging any mistletoe because he won't be standing beneath it with me yet. I close my brown eyes and feel the kiss anyway. *Feel the love.*

*18 December, 1998*

*Sweetie, hello! Our first meeting is getting closer. It doesn't scare me, though I am very overexcited. You have become so close for me that it seems to me that my home (it's amazing) is not here, but near you. I have never had such wonderful feelings. I am fine and very busy here in the hospital. I have a lot of therapy each day and it is not easy job. On weekend I will have the rest at home. Don't worry. Nothing can destroy our love and plans. Soon we will be together. Say hello to your family. I love you and feel your love very deep.*

The most important thing is that you get well soon, Valentin. My love and prayers surround you. *I'm with you.*

*18 December, 1998 10:00 p.m.*

*My dearest Janet, hello! I am at home on the weekend after the five day's "rest" in the hospital. The hospital is one of the best in the city and my friend Vladimir is my healing physician. I was so busy all the days in the hospital that I fell asleep at 10:00 as after a hard job. I have been getting a lot of therapy every day; the massage of the back and legs, the needles, the electrotherapy and many analysis of blood pressure, etc. before dinner, the medical exercises and swimming—both before supper. It is as a real working (but more than 12 hours) day! But I am quite well. You are helping me every moment and I feel your love and support, the warm of your spirit. I miss you so much. I am falling asleep, hugging you tenderly. Goodnight, my Honey.*

*I feel the warm of your spirit, too, dearest Valentin. I miss you and I'm feeling the tender hug as you fall asleep. It's hard to sleep, though. What is it going to be like with your strong arms around me?* I pondered the possibilities. Was a tender Russian hug close to anything I'd ever known?

Probably not. Those tender Russian hugs might make my hot flashes feel like warmed-over chicken noodle soup.

*20 December, 1998*

> *The days have passed as one hour. Today I was in the yacht club all the day. We tried to sail on the ice-boat, but the wind was very light. The weather had changed since Tuesday. On weekend it was warm and rainy after the frost. The white, pure beauty had exchanged to gray and gloomy colors.*
>
> *There is a tiny church of St. Nikolas near the club. I prayed for us. My Honey, it doesn't matter for me the church we will visit. I am not so religious. For me all churches are equal, they have been created by Man. And the Father created Man and everything outside and inside us. I can speak (and speak) with God everywhere and at any time. Don't worry about this problem. It is not the problem.*
>
> *I am very glad that your Dad is quite well in spite of his serious disease. He is the strong man. I know it is not easy, but be patient with him. I am eager to help you. I dream to visit him with you in his beautiful mountains. I love mountains, maybe more than sea. I am sending you my love and devotion. I close and start to the hospital.*

Dad's cancer wasn't making life easy for him, or for anyone else close to him. I talked to Val about my struggles trying to make my father's life more comfortable. It wasn't always easy to be patient, but I tried. We talked more about life and God and our families and I felt convinced that this man didn't come anywhere close to my preconceived stereotype of the Russian ex-communist. Our communication thus far showed me a deeply spiritual person who was wise and thoughtful and caring. Her book on Russian-American marriages couldn't possibly fit us. I brushed her words aside; "Psychologically it's not easy for a former Soviet citizen to become an American. I don't even know if it's possible."[5] "No matter how close Russians and Americans may at times seem, there is always the chance our respective cultural differences will rise up to divide us . . ."[6]

This author may have a Ph.D. from Harvard and taught Russian language and literature at Columbia University, but it's clear she hasn't encountered a Russian

man like Valentin. How could our cultural differences rise up and divide us? How could anything divide us? Maybe I ought to write the next book on Russian-American relationships!

*22 December, 1998 3:00 p.m.*

*Honey hello! Today is the shortest day (light day) of the year. Tomorrow the day will be increased by one minute and so on, then spring . . . and the new circle of life. I have had dinner and now it is "the quiet hour." We must go to beds in our rooms for one hour. On Christmas I will be at home and at Home with you, Darling. I want so much to create our Home of giving and receiving—family life is a matter of give and take. Our love will help us. I will be patient.*

*Happy New Year to you and your family. I close and will mail this off after the sleeping. Be very joyful. I love you.*

After the sleeping? Who is sleeping? The joyful is keeping me awake.

*23 December, 1998*

*Dear Janet. One more "quiet hour," the last one in the hospital. Tomorrow I'll buy a Christmas tree and decorate it. My father did this every year with pleasure and now I do. It is a wonderful tradition and gift. But the greatest gifts are our love, your son and his wife's future baby and beautiful Nature around us. Happy New Year, my Dearest! Soon we will be together. Thank you for being. I love you.*

I love you, Val. Now I know it. Somehow it seems impossible to love a man I've never met. Yet, I do love you and in a way, I feel as though I have already met you. We have been talking and loving each other even though we have never physically touched. This is magic and for me, a Miracle.

*25 December, 1998*

*Christmas Hello, Sweetie! Thank you for your letter on December 14th. I have finished treatment and I am okay and ready for life not only in the Wild West with Calamity Jan, but in the cozy, quiet house with Janet Lynne, too. They are both so exciting! I hurry to them. I am going to be in Seattle on January 15th. I will buy a ticket next week. Don't get a scare. I'll be a good boy. Merry Christmas to you and your family. I am hugging you and feel you beside me. I am sure our dreams are coming true! I LOVE you.*

Oh, my gosh. January 15th. He's coming. He'll be here in my house in three weeks. THREE WEEKS. *I think I'm getting a scare.*

*30 December, 1998*

*Dearest Janet, Hello! A Happy New Year! I like your fine dream, but the reality will be beautiful. I miss you. I'm very glad your Christmas has been wonderful. I was with you and am with you now, too. I feel you so close.*

I'm celebrating the New Year with a few friends who now know this proposed Russian book project may involve more than editing, translating and marketing children's books. They are happy, but skeptical. I am happy and scared.

*1 January, 1999*

*Good morning my Dearest Janet. The New Year begins and our new life is beginning. Best wishes to your father. I hope to meet him soon. I miss you a lot. I will be in Seattle on January 15th at 11:45 a.m. It will be the last—first step to you. I love you. We will be happy. Val*

*Can this really be happening? What if I faint before I see how blue your eyes really are, Valentin Gudkov? What if I flat-out melt on the floor at the Seattle-Tacoma International Airport?* I throw my mind back onto reality and focus on things that won't make me crazy.

Okay. Dad knows I will be bringing a Russian man to visit him. He holds off his opinion until later, but asks me a few key questions including, "Can he prune fruit trees?"

*11 January, 1999*

*Sweetie, hello! Thank you for your e-mails. I could not answer you in view of disorder in Internet communication. Today it is all right. See you on Friday and you will be convinced of my reality. Please don't be very nervous. I'm with you, though I'm nervous, too. With love, your Valentine*

# CHAPTER THREE
## Doing a Risk

*Without some risk, our life becomes tasteless. Do a risk,*
*please, Jany.*
—Valentin

*Seattle Tacoma Airport*
*15 January, 1999*

Had we both made a terrible mistake? I walked beside
this stranger from St. Petersburg, gripping one piece of his
luggage and fighting to keep the tears and shattered
dreams from exploding behind my lids. *God, what am I
going to do?*

I scarcely remember the two-hour trip home in heavy
traffic. When we arrived, my sheltie barked at the strange
man walking into her house. *He is going to be sleeping in
the guest room across the hall from us, Cider,* I said
silently, trying to quiet her bark and my pounding heart.
*We'll be just fine, Cider. Fine.*

Exhausted after twenty-two hours of Immigration
lines and flights, he took a few bites of the meal I had
prepared, thanked me graciously, then showered and
retired to his room and slept fourteen hours. Cider curled
up on the rug beside my bed, small growls escaping from
her doggie dreams throughout the night. She knew
something was amiss. I heard her every growl and snort
because I didn't sleep much, either. My mind reeled with
the confusion and doubts that had hit me so unex-
pectedly. My heart ached. How could the months of tender
letters and dreams disappear on a frozen wind somewhere
beyond my heart? Did he feel the same? I still loved him,
*knew I loved him,* but something had gone terribly wrong.

After breakfast the next morning, my spirit calmed
somewhat. Valentin had won my little sheltie's heart and

slowly began to draw me toward a safer, softer place; *toward the man I thought I knew from the letters and my dreams.* Slowly, very slowly we began to find our way, but not completely. Although the physical attraction was strong and although I knew I loved him, something was missing. Something deep in him wasn't there and in the center of my being, I knew it. *What was it?*

We began to work on the proposed book project. Walks and talks together with Cider through the wooded trails and beaches drew us closer and finally convinced me that in spite of those uneasy feelings, I loved him and wanted to build a life with him. What drew me, perhaps even blinded me? Was it more than physical attraction?

I believed it was. Now and then I touched the deepest part of him and found that same depth I had known from his letters. But the glimpses and the beauty escaped like shards of light in a deep forest and although I tried to hold on to them, I could not. The only pure reality seemed to be the strong arms and sweet kisses.

One day in the soft place of his arms, he asked me to marry him and I said yes. I didn't want anything to spoil the warm and bright morning of our love.

"I love you, Kiska."

*"I love you, Valentin. I love you . . ."*

Two weeks later he returned to Russia to discuss our book project with his company, take care of his mother's needs, and prepare and pack his belongings for the new life in America. We planned to marry in June. He carried back some gifts for his family and a few loaves of my homemade bread. It was during this time while he was in Russia that I struggled with my deepest feelings that all was not as it should be. His highly active and intense demeanor and somewhat demanding behavior might only be temporary after life settled down, I argued against my gut-level warnings. I recalled one letter where he said that being too active was one of his *demerits.*

Then there were the times I remembered finding myself exhausted preparing the meals he required due to his digestive difficulties, yet because I loved him, I wanted to do everything I could to make his life better. Besides, he agreed to help in the kitchen when he wasn't working, promising we would be partners and share some of the

responsibilities. His borscht was wonderful, and when it came to a recipe for romance, this passionate Russian didn't lack much. Sometimes, though, I just wanted him to hold me with those deep blue eyes and hear the same tender words he shared for so many months in his letters, but in reality, those emotional connections were very hard for him. *Why?* I wondered. I loved him so much, but now I was beginning to wonder if his love was as strong as mine. His moods (withdrawing) troubled me as well. I decided it must be because he was missing his family and his homeland and felt that time and patience would make a difference.

By now, I felt sure the age difference wasn't an issue. The physical attraction (at least for me) was strong and I wondered if that was what held me—perhaps even blinded me to some deeper issues I needed to face.

"While Russian intensity can be attractive, it does not make for easy living," author Visson says in *Wedded Strangers.*[1]

*Dear Lord God of the Universe, I hope this author isn't talking about us.* The book continued to disturb me and I didn't want to read it much anymore. I didn't want to face the grim possibility that this Russian relationship might be headed for troubled waters.

*St. Petersburg, Russia 18 February, 1999*

*Hello Kiska! I love you and am missing you so much. Katia, Vadim and Mom enjoyed your gifts a lot. The weather is not very cold but I am cold without you. I am so close to you every moment. I hug and kiss you many times.*

His tender words caught my heart once again. How beautifully he put his feelings into words through his e-mails and letters! Why didn't I feel the same strength and power of him when we were together? Something was not quite right. The possibility that he didn't love me as much as I loved him felt like a slow knife in my gut and confirmed that I needed to hold off the marriage until I could be sure.

I wrote him and shared my thoughts and concerns, suggesting that we consider delaying the June wedding

and give our relationship more time. I asked our mutual friend, Irina, to call him and talk to him about this as well, because I knew she might be able to express it better in their mutual Russian language. She did.

*St. Petersburg, Russia 22 February, 1999*

*Hello my Dearest! Please, be peaceful and don't think so much about negative moments. Do wrest the painful knot from your heart and be calm. I'm with you. I love you and God knows it. I want to share everything with you, Sweetie. A new life there will not be so easy for me and needs so much strength from me. It is easier to stay in my old life here, but I desire to be with you. I am very busy with work and like it. I have no time to think, only to work. We are still eating your bread. It is very tasteful. I miss you a lot.*

His letters, phone calls and e-mails calmed me somewhat, and I decided to move ahead; not just because I loved him, but also because the visa had been hard to obtain and we might not get another one for a long time. When a woman is 61 years old, she doesn't have a swarm of years left on her doorstep. Still, I wished we could have more time to get to know each other. We discussed some of the things that might be facing us, including the age difference and cultural disparities. I loved him deeply and prayed we could work through these problems together.

*5 March, 1999*

*Hello my Sweetie. I am missing you so much every minute. I love you stronger and stronger from day-to-day. You are the only woman I want. Honey, don't be afraid of our difference in ages. I am not so young as you think. Russian men are older than American (at the same ages), because of our not-so-easy life over here. The average man's lifetime is about 56 years. It's a pity. I want to live and will live longer, because I have you, love you and want only you. Our future will be happy and marriage—secure.*

*I work very hard now (full time and overtime). I leave to the office at 8 a.m. and go back at 9 p.m. I want to make some extra money for our rings and for supporting Mom and*

*kids after my departure. I am going to get to Seattle as we have planned at the end of May or the first week of June. Sorry I am falling asleep. I am so tired. Goodnight Dearest Jany. I am hugging you . . .*

Okay. *Okay, we can do it.*

It was comforting and strengthening to stay in touch by letter and phone, although it wasn't always easy to connect with his heavy work schedule and phone lines that weren't always open. Irina continued to be a good friend, encouraging and advising me wisely during my days of waiting and preparation.

*I can do it.*

*7 March, 1999*

*My tender Kiska, hello!* I scrunched back in my chair, reading his letter. Kiska meant "kitten/kitty" in Russian and became his pet name for me. *It was so nice to hear your voice. It will be great if you call me sometimes. This weekend I stay at home. I was so tired during the last week. After our phone talk I have become calmer. Honey, I am not the ideal person (I have the demerits), but I am not so bad. I want to be near you for many years in this beautiful world. I don't want anything else. We both were single for many years and it's not easy to begin the new life, but I am sure that we <u>must</u> be together as soon as possible. God helps us and we will be patient to each other. I miss you so much and want to feel your warm body and soul every day. It's very hard to be so far from you. I love you."*

In our letters and e-mails, we talked more about our lives, our past marriages and the issues that were going to be important in this new relationship, this new life. Trust and honesty were so basic for me and he assured me it was the same for him. We agreed to embrace our highest values and that we would anchor our marriage on our mutual faith in God. We also agreed to seek counseling if there were problems we couldn't solve together.

*12 March, 1999*

*Hello my Dearest. I want to share our wonderful life and love for as long as God gives us—forever. I love you completely and for always. I miss you and am eager to get started on our new life. I miss your cooking, bread loafs, evening fire, and you. I love you completely and for always.*

Bread loafs. I smiled at one of our first (minor) cultural collisions. I had baked a fresh loaf of bread and sliced it while still warm, looking forward to pleasing him with one of my domestic miracles. He didn't want it, setting it aside and separating the slices on the counter so that they could cool down and dry out. "This shall become more tasteful in a few days," he explained. I buttered mine while still warm, then slipped a few slices into a Ziploc and sealed them to keep them fresh for me. Not a problem.

*22 March, 1999*

*Hello Honey! Although I'm working hard and preparing all my documents, I'm quite well, because I feel your love and support every minute. I miss you and our nice connections, too. I'm sure we will be together soon and forever. I love you, Kiska. Mom wants we will be together and blesses us. I love you so deep. Thank you for your nice call and the long e-mail. I need them so much. I reserved the return ticket on 30th of May and hope that present political events don't prevent our meeting. God will help us. Say hello to your family and Irina. Be joyful my sweetheart. I kiss you many times.*

The crisis in Serbia including the NATO air attacks made the world (and us) uneasy. I focused my energies on finding a nice outdoor setting for our ceremony. My brother, a pastor, agreed to marry us.

*1 April, 1999*

*Hello Kiska! I agree that the simple wedding ceremony is the best way. I miss you a lot and dream of you. I love you! I am going to finish my job at end of April. May will be*

*the month for documents, work in the village and some rest.
I will try not to be too tired when I arrive.*

I found a woodsy park bordering a lake with a
charming log building beside a creek for the ceremony and
reception. If weather permitted, we would marry in the
meadow near the creek and wooden bridge. Once my
children realized there was more than a book project going
on with this Russian man, they graciously accepted the
inevitable and my two daughters agreed to be my
attendants. My son Blake, now a pilot, had more on his
plate than this Russian and his mom getting married. He
and my daughter-in-law expected their first child close to
the date of our ceremony. "Don't count on us, Mom," he
said; and of course, I didn't.

*5 April, 1999*

*Hello my Dearest. It was nice to get your e-mail
Saturday morning. I feel your thoughts about our marriage
ceremony. I share all your plans and ideas. I think it must
be as simple as possible. Congratulations with Easter. God
helps us. Be safe and peaceful my Honey. I love you and
kiss you so many times.*

The plans for the ceremony progressed well, but the
decision to publish the books in Russia got put on hold.
Because of the troubled Russian economy, the news
wasn't unexpected. I sent a package to his mother for the
Easter holidays. Easter, for many Russians, is even more
important than Christmas.

*9 April, 1999*

*Hello my Sweetie. Thank you for lovely letter, Mom's
gifts, your call, and last e-mail. Mom is very glad and sends
you best wishes and hugs. It was nice to hear your voice
and feel you so close. I'm missing you so much and dream
to hug you and feel the warmth of you. I'm so tired here
without you. You are God's gift for me. I love our little
miracle place for wedding you have found. I love you
forever and treasure every moment of our connection.*

*Happiness is our journey. Let's love like we've never been hurt.*

*Thank you for being.*

*Happiness is our journey.* His tender words wrapped me up once more, warming and strengthening me for this new life journey. I treasured this connection and knew that even though I had still had a few qualms, I was ready to love like I'd never been hurt. Both Val and I had been hurt, especially in our past relationships, so we talked about that and decided we were both ready to put the past aside and move on. I felt so much better after our talks, even if they were mostly by e-mail and phone now. I loved him so much.

*16 April, 1999*

*Hello my Dearest! Although I'm very tired and have lost two pounds, I'm quite well. I'm eager to take some of your extra pounds and help you in your funny trouble. Be very calm. I love you as you are, my Kiska. The spring comes, but it's not warm yet. Here are not leaves or any flowers. Mom is far better and begins to think with pleasure about summer life in the village.*

My funny trouble. I'd bought a chic burgundy dress for the wedding, but I couldn't wear it until I lost some weight. Since he was such a slender, firm-bodied guy, I suggested that maybe he could have a little of my fat.

I'd purchased a bread machine when he'd first come to stay and now I wanted to kill it. Yet maybe the Russian way wasn't such a bad idea? If I allowed the fresh warm bread to get dry and hard first, maybe . . . *Be very calm, Calamity.*

*22 April, 1999*

*Hello again my Dearest! Today is a nice warm day, about 70 F and so sunny. Tomorrow Mom and I will go to the village. Soon we will be together for always and I thank God who brought you to me—to our world. I'm sure the best years are in future. I love you my Kiska.*

I splurged and purchased a second-hand motor home because I believed it might be a wonderful way to Honeymoon and also give us a chance to do a little traveling before we settled down and he found work. I hoped he would enjoy the surprise; our dacha on wheels!

The simple ceremony involved a lot of preparation. Although I had amazing friends to help me with ordering the cake, food, music and sending out invitations, it still took a lot of my time and energy. My pre-bridal dance was hardly a thing of grace and beauty, but Calamity still had her boots on.

*23 April, 1999*

*I got up at 8 a.m., left to the village at 10 a.m., and was there in four hours. The weather is colder here and it rains. Here are no flowers yet but trees and bushes are beginning to shoot. The river is full, six feet higher than usual. Here was a lot of snow in winter. I have done some job in the rain. Now I'm sitting near the fire so close to you. I communicate with you through the ocean. Communication is even <u>more than everything</u>, I agree. But sometimes it is so hard for me to express my feelings and thoughts in English. My English language is not so rich. I know you understand me and will help me. We will be very patient. I hug and kiss you many times. Do you feel it? I'm calm and happy—I have and love you.*

He did love me. How could I have doubted it? His words—his spirit wrapped me up and held me as I thought about our future together and the challenges we might face. He cares, maybe more than I know—he just doesn't know how to get those feelings out there when we're together. I would be patient. I loved him so much and wanted our marriage to work, and I knew he wanted the same. My heart felt so connected now.

Curled up by the cozy fire, I read his letter again, missing him and wondering what it must be like in the village dacha by his fire. I didn't know then that I was going to find out—much sooner—and under far different circumstances than I'd expected.

*24 April, 1999*

*I have done a lot of job here. The first day was very rainy, the second was cold, sunny and dry. Mom is quite well. She cooked and did some job in the vegetable garden. I pruned apple trees, shrubs and had enough sleeping. I relaxed and I am ready for hard job in the city.*

*How are you my Calamity? Don't trouble about the ceremony. The main thing is that God has given us to each other and soon He will connect us. Be peaceful and safe, my Honey. What about your books, car, bread machine and etc.? Soon you will report me in reality. Be ready. I'm eager to share all your problems. I hold you so close and want you so strong. Be very calm and healthy. I love you.*

The books; selling well. The car; repaired. The bread machine; I haven't killed it yet. The small, simple wedding ceremony was trying very hard not to be small and simple, and Cider had a small tumor on her leg which might be cancer. Surgery had been scheduled for the following week. *I am healthy my darling, but I am not ready and I am not calm.*

*27 April, 1999*

*Sweetie Hello! The short rest is over. Thank you for your so warm and long e-mail. Poor Cider, I love her. When we are old, we will try to be young and be closer to each other and Nature. We will share all troubles and nice moments.*

*Yesterday Katia phoned from Moscow. She and Vadim will come to St. Petersburg on 2nd of May. She has asked Mom to keep Vadim with her for summer in village and Mom has agreed. I'm glad she will not be alone. It will be easier for her to adapt after my departure.*

*I've bought the ticket. I will be in Seattle on 30th of May. I hope you'll meet me healthy and without secret photographers. Best wishes to little angels, Dad, Mom and all family. I squeeze you tight, but tenderly. I love you, Jan Calamity.*

I feel the love. He will return. Soon. *I've missed you so much, Val. So very, very much.*

*25 May, 1999*

*Hello Kiska! You are the best Gift from HIM. Thank you, God. I feel you every moment. It's a pity you could not get me by phone! Soon we will be together forever! See you on Sunday.*

# CHAPTER FOUR
## East and West Collide

*I'd read somewhere that only children, especially European men, are often labeled "Little Emperors." I wondered if I had married one.*
—Calamity Jan

Valentin and I were married on June 12th, 1999, under a warm summer sky, in a simple ceremony. Just before we said *I do,* a cell phone interrupted with the news from my son that a 6lb 3oz baby girl decided to share in this momentous occasion. My son Blake and my daughter-in-law Patty's first child, Rachel Mackenzie Pierson, joined us as we laughed, cried and spoke our vows. Following this, three of my granddaughters sang a romantic wedding ballad and were as angels until the second stanza when their halos fell off and they burst into giggles. Between cell phones, celebration, fractured love songs, and laughter, the day was nearly perfect.

And so was the night. Returning home, we built a crackling fire, toasted with a glass of red wine, opened gifts, danced a little, and loved a lot. The FBI and the KGB began making beautiful music together.

The next day we drove off with Cider in the motor home (christened the *Loaf* by Val) for a wedding trip around Washington State's picturesque Olympic Peninsula. Cider had recovered well from her surgery and found her special bed in her new home on wheels. Although it was cancer, the vet believed he had gotten it all. Calamity Jan, the Russian and the little sheltie parked in campgrounds on lakes and beside rivers, hiked trails, walked the beaches and cooked by campfires. Val, an expert swimmer and lover of water, dove into every lake, river, stream and ocean along the way. The glacial shock of cold invigorated him and gave him the perfect start for

his day, which began with his morning exercises. I thought my Shetland sheepdog was high-energy, but that was before I met and married this man.

I remember Val's first roadside swim. We pulled the motor home over to the side of the road and Val hurried down to the river's edge, stripping naked and diving in. I rushed down with a towel. "Honey, in our country, people get arrested for this!" He thought this was a foolish law, but agreed to wear his swimsuit after that and (gulp) most of the time he did.

Difficulties began when the driver of the *Loaf* emerged as Commander-in-chief, rather than husband and friend. "I told you to lock the door behind you," he ordered one afternoon after we had stopped at a gas station to fill up the gas tank and pick up some groceries. "You shall do as I say." He was sitting in the driver's seat, and I had come inside to put groceries away. I failed to lock the door behind me—probably because I was going right back outside. (Before our travels we had agreed to keep the door locked.)

"What?"

"I told you to lock the door at all times." It was a command.

I drew a deep breath and wondered if this was a Russian thing. Well, if it was, the KGB and the FBI were going to have a meeting.

"Val," I said, setting down the groceries with a thud, "next time you can simply ask and remind me. This is new for both of us, Honey, so let's try to be patient with each other." After my previous marriage had ended, some counseling had helped me to learn how to open up and express my feelings better. I determined never to allow myself to be controlled in such a way ever again. I'd made a lot of changes in those thirteen years of living single, but the real test was now on my doorstep. I had divorced a school principal and married an ex-communist.

*Good grief, Calamity—didn't you learn anything in college, grad school or LIFE?*

I recalled something Val said in one of his letters about his faults. He called them *demerits,* and at the time I thought that was a rather charming way to talk about

his imperfections. *I have some demerits. Too demanding with Mom and my kids, etc.*

Suddenly the demerits began creeping into my world like little sword ants. This wasn't the first incident and now I began to wonder if the landscape was changing more than I liked.

My thoughts backed up. Our second night on the road we had parked our RV in a state park and as night fell, I began to pull the blinds down for some privacy. He immediately raised them and explained that he did not wish for us to keep nature away, pointing upward toward the stars and moon. It was true—the sky was wonderful that night, but I still didn't like the people walking past our windows and glancing in.

"We're right here beside the walkway to the restrooms, Val. Hey, this is our honeymoon!" I was ready to get into my sexy nightgown, but now I was having second thoughts. I made some clever remark and began to lower the blinds again.

"No," he said, raising them back up. "We shall keep the nature around us."

I drew a long, slow breath, then turned and headed toward the bedroom. "Okay," I called back. "I need to find a place to undress and sleep, so I'll be back here if you want me more than the moon and the stars."

He didn't.

Before I drew the curtains in the bedroom, I glanced out at the night sky. It was beautiful, but I wanted some privacy. This was our honeymoon! I didn't know whether to be mad or cry. In hindsight, I wish that we could have taken a walk and talked this out instead of sleeping separately as we did that night. We did need to talk. Things had been building already, and the honeymoon wasn't even over. Or was it?

The next morning it was as though nothing had happened.

"Good morning, Kiska!" he said with a bright smile as I stumbled out of the bedroom after a sleepless night. He was on his way out the door to do his morning exercises.

I stood in a fog and watched him head out toward a clearing. He appeared to have had a wonderful night's

rest. *How can he do that when I've been lying awake (and alone) all night?*

When he returned, we had breakfast and moved on to the next campground, not discussing the issue again. I brought it up just once, but he immediately ended the discussion.

"Why do you wish to create problems when there are none?"

After that we kept the blinds open in the main area night and day, but I drew them in the bedroom each night. I knew he was not pleased, but he still loved me more than the moon and the stars most of the time.

More Commander-in-chief incidents occurred and made me uncomfortable and when I tried to talk about my feelings and concerns, he reacted strongly. "We shall not discuss foolish problems that do not exist!"

But problems did exist, and they were building inside of me (and him?), and I knew we must work this out before it began to hurt our relationship. I realized he was very accustomed to getting his way and when he didn't, he either struck out with words (blaming me for the problem) or withdrew. I'd read somewhere that only children, especially European men, are often labeled "Little Emperors." I wondered if I had married one.

As soon as we returned home from our wedding trip, Val began to seek employment. Although he had graduate degrees in physics, engineering and secondary education, he didn't want a high-stress job in a foreign country because the cultural, technological and language differences were challenge enough. I understood and helped him with the process since everything, including the job search and application process was completely foreign in this new culture. He had never written a check and the paperwork setting up his social security, getting job applications filled out, insurances set up, and other things were definitely stressful. After weeks of searching, he found a job working as a groundskeeper for a mortuary in a city nearby. The pay was low and the commute was long, but he liked it.

This was a relief for him and for me. During the past weeks together, I found myself exhausted by day's end. "Will you help a bit with some of the meals, Honey?" I

often asked. Although he had first agreed to share with the cooking until he found work, he resisted this except occasionally when he felt inspired to prepare a wonderful borscht or special Russian meal, which usually only happened when we had guests. Most of the time, I did the cooking.

Because of his digestive problems due to ulcer surgery, he required special foods and insisted they be prepared and presented in a particular way. Because of his health issues, and especially after he had found work, I truly wanted to do as much as I could, but I was now spending more and more time in the kitchen and scarcely had time to write anymore.

"We shall share all meals together at the table, three times a day," he said one morning as I was carrying my bowl of oatmeal into the office to check my e-mail.

"*Really?* I drew a deep breath and exhaled slowly. "Are you saying you want to sit down at the table for breakfast, lunch and dinner—THREE times a day?"

"Yes."

I gripped my oatmeal tighter so it wouldn't spill or do something it shouldn't. "Okay, Honey," I replied, walking back into the dining room and sitting down at the table. "This is such an interesting idea." I had been grabbing plates of anything and hurrying to the computer or to catch the nightly news on TV for years! *But, maybe it wasn't such a bad idea.* "I guess we can do that," I said finally, watching him dish up his oatmeal and come to sit across the table from me. "Sure."

Because of his poor digestion, he also informed me he wanted the food to be served at room temperature. Sometimes I'd forget to get the milk and cream for oatmeal or something else out of the refrigerator an hour before eating, which highly displeased him. I quickly learned sneaky ways to accomplish this by using the microwave to warm things in seconds. Breakfast required his specially prepared grated and cooked beets mixed with grated raw carrots blended with olive oil, which was to be the first course. I decided to cut down my preparation time and instead of cooking beets and grating raw carrots each morning, I cooked and grated enough vegetables for three days, storing them in the refrigerator. I thought it was a

great time-saving idea, but he didn't and insisted I prepare them fresh each day. We had another one of our disagreements, which ended when I gave him a choice: either let me fix this in the way that saved me time, or fix it himself each day. Clearly he was not pleased. By this time I began thinking about this amazing Russian mother who undoubtedly met his every need. *Dear Lord, how did she do it?*

He wanted raw, non-pasteurized milk, so we finally found a farm nearby and got a gallon each week for him. He was overjoyed, except when he realized that if he wanted yogurt or cottage cheese to be prepared in the special and time-consuming Russian process, he was going to have to do it himself. I was a partially liberated woman now, even though I still cooked most of the meals, baked killer apple pies and homemade bread. I watched (and smelled) as the little bags of cheesecloth he hung from our lower kitchen cabinets allowed milk to drip into containers below, draining and aging the yogurt and cottage cheese properly.

"Yes," Irina told me, "his mother did all of this for him. She spent many hours preparing all of his meals."

I began to understand more and more.

One day upon entering our guest room, I discovered leaves all over the white embroidered bedspread and the floor.

"Linden leaves for tea," he explained. "There is a wonderful tree across the street. We are very lucky to have this."

"Oh."

Shortly after we returned from our honeymoon, he had raised every Venetian blind in the house, but then he began to move the furniture around and suggested pulling up the wall-to-wall carpets to expose the wood (plywood) floor.

"Wood is natural and better," he stated, after I explained that yes, it was a wooden floor.

"But it's plywood, Val. This wood isn't as nice as some of the fine hardwood floors in Russia. This carpet should be fine."

"No," he said, moving the couch toward the middle of the room.

I knew I was going to have to plan a new strategy. "Val?" I said, staring at the oddly-arranged (in my opinion) living room. "I have an idea. You may have total freedom in the yard, and I'll have total freedom inside the house. What do you think?"

He was mildly displeased; but agreed, since he did love yard work and now would not have to listen to my suggestions that, for example, he mow the lawn. (It was almost a foot tall when I intervened the week before.) "This is now becoming like the village!" he told me.

He now had the freedom to do anything he wished outside. The yard might soon resemble a Russian dacha but by this time, I really didn't care. I just hoped our neighborhood association was okay with it.

We got the furniture moved back into place, the linden tea turned out to be delicious, I began to get accustomed to the smell of sour milk wafting through the house, and I liked the new look in my yard. (He did mow, finally, and turned out to be a wonderful gardener.) I also kept the blinds up, except in our bedroom at night, enjoying a brighter house by day and moon by night.

But, the honeymoon was over. Clearly it was over.

I was making some sandwiches one day and couldn't find the mustard. "Val, do you know what happened to the mustard?"

"I put it in my socks," he replied.

"In your socks?" *I couldn't believe this. What next . . .*

"We must get more. It is very healthful for my feet."

Val was occasionally troubled with aching joints and preferred non-traditional home remedies. I'd heard of mustard plasters, but never . . . *mustard socks.* He stood there so innocently, as though we were talking about aspirin or Preparation H. "Have your feet been aching, Honey?" I asked stupidly. I couldn't think of anything else to say. For better or for mustard, I loved this guy so much.

"Yes, and the mustard is very helpful."

I finished making the ham sandwiches (without mustard) for our trip up the Washington coast the next day. We walked the beaches, picked up a few clams and colorful rocks and brought home a beautiful nine-pound salmon from a coastal cannery. I'd forgotten about the

mustard socks completely. It was a good day and I could almost taste that barbequed salmon already!

The following day I took the fish out of the refrigerator and began to prepare it; intending to slice some for steaks and cut up and freeze the remaining portions for baking.

"No, Kiska. I shall prepare the salmon," he said, waving me out of the kitchen. "I shall take care of everything in the Russian way."

This should have been a huge red flag, but it wasn't. Watching him put on an apron and take over in the kitchen thrilled me to the core. Russian, Norwegian, Kukamungan; I didn't care. I hurried away before he changed his mind, escaping into my office to finish a writing project.

The next morning I stumbled into the kitchen to make the coffee and discovered the filleted salmon lying all over the counters. *Oh my gosh, he forgot and left this out all night.* I lifted the cheesecloth and drew back. *It's beginning to stink . . .*

"It will be just right in a few days, Kiska," he walked up from behind. "I have salted it well."

*Our beautiful salmon . . .*

But there was more, and it was much worse than raw fish and mustard socks. Little white lies began to wriggle their way like worms into our lives. We'd already talked a lot about trust so he knew that for me, deception, secrecy, lying, even *innocent* little white lies in any form were a deal breaker. He had to stop or our relationship could not survive.

But this had already become second nature to him, and I didn't know what to do. Now I realized that the author of *Wedded Strangers* was talking about us. Visson notes in her book that the Soviet system fostered a reflex response of lying. "The soviet government and press lied to the people, bosses lied to their wives about everything from infidelities to drinking up the household money. Lying became second nature, a form of self defense."[1] In Russia, infidelity was the rule, rather than the exception. Author Visson, herself raised in a Russian-speaking household, goes on to explain; "The ideal of total honesty that is professed in many American marriages is alien to the Russian mentality."[2]

I didn't like the dishonesty and secretiveness, his demanding behavior; nor did I like the arguments that gradually began to darken our days and nights. The romance and passion faded as we became combatants in subtle, emotionally-fueled wars. I remember sitting in the chair by the fireplace gone cold, feeling beaten down in my spirit after another one of our arguments. "Val," I said. "What's happening to us? Can't we just be partners and friends?"

"No," he said. "I have my partners and I have my friends. You are my wife."

"What about all your letters, what about all that love—all those beautiful things you said to me?"

"Those were letters. This is the reality."

His words knotted the deepest place inside of me. I felt spent. Hurt. What had happened to us? What had happened to the love that had been so tender and amazing during those earliest days of our correspondence? Was the authoritarian mindset and the lying a cultural issue, or a form of self-defense? I didn't know, but I couldn't continue. I didn't want to lose this marriage, but I didn't want to lose myself, either. I began to stave off the Cold War by wrapping myself up in my own little iron curtain. I didn't like who I was becoming. Hard, unbending and afraid, I found safety; but not solace in this fight for my life and my marriage.

Val found solace in other Russians. Irina and her family and friends were important in keeping his connections with his homeland and heart. Sometimes I shared these times and these friends with him, but as time went on, I became less and less a part of his world and I knew he wanted it that way. I also sensed he was missing Mother Russia, his family and his friends across the ocean and although I wanted to do something, I didn't know what to do. I noticed that often when I displeased him, he would leave or get on the phone and connect (speaking in Russian) with one of his friends who, I'm sure, gave a sympathetic shoulder for him to lean on. His moods and periods of withdrawing from me increased and our arguments escalated and sent us both deeper inside ourselves until we became as strangers.

Psycholinguist Deborah Tannen says, "Many cultures see arguing as a pleasurable sign of intimacy."[3] Arguing with Americans, however was no fun for the Russian spouses. "Everything was *I think that,* or *perhaps.* Couldn't they state their position forcefully and stick to it? The Americans found the Russian style of debate aggressive and confrontational. The Russians found the Americans weak and indecisive."[4]

I didn't want another argument as long as I lived, yet he insisted this was healthy. We tried to find peace and compromise, taking short weekend trips to the mountains, beaches and lakes or sometimes visiting my family. In spite of the trouble looming over our horizon, I still cling to some happy memories of those days and weeks. Most of my family, including my mother, had come to accept and love him. Dad said that Valentin could prune trees better than anyone else in BZ Corners. We visited my church and his—praying and lighting candles for our families and each other, but nothing seemed to help, nothing erased his nostalgia and pain, and mine—nothing healed the emptiness and the anguish and differences that were beginning to separate us.

*God? Christ? Where are you? Resuscitate us please!*

What happened to our love? Our faith? Our dreams?

Val refused to discuss our problems or get counsel. "Russian men do not go to counseling," he said firmly after I suggested (once again) that we get someone to help us. "We shall not talk of this again."

I didn't.

Still, I tried to understand what had happened—why the reality of our relationship didn't resemble our earliest and tender love connections by e-mail and letters. His secretiveness and withdrawal threw me into an emotional tailspin, and I watched my own insecurities creep out of their hiding places and begin to affect me. Affect us. He didn't wish to discuss his phone connections with me and wished to spend time with his friends without having to be accountable in any way. "Some things must be absolute private," he told me later on in a letter. Was this the Russian way? As I tried to gain control of myself and make sense of this growing dilemma, I found myself becoming more insecure. Although I never believed he was sexually

unfaithful, once he began to withdraw from me, I felt more and more uncomfortable with his emotional connections with other Russian women and his refusal to be open and honest with me about those connections.

"In America," one Russian woman said, "you run to psychiatrists because you do not have the tradition of close everyday friendship that we have in Russia . . . We share everything with one another, hiding nothing or very little. We like to share our sorrows, we love to feel sorry for and help one another."[5]

Was this happening to Val? Was he sharing his heart with them? If it was true, why did he have to lie about it? I wanted so much for us to talk. I wanted to understand. What threw us off and why did we begin to fall so fast and so hard?

Lynn Visson states that different concepts of intimacy can cause serious misunderstandings. "Russians do not like to engage in detailed analysis of their feelings towards each other with their spouse or lover."[6]

"Russians believe that people should solve problems and conflicts on their own, or with help from friends."[7]

"For Russians, true intimacy lies in the silence of a couple who understood each other by a look or a gesture."[8]

Yet the silence and the misunderstandings were killing us. We needed to talk, but Valentin attacked me verbally whenever I tried.

"Do you see how YOU are creating problems when you bring these troubles forward? Everything has been peaceful, then you wish to bring great explosions into our peace and calm!"

These encounters taught me to wait for times of peace rather than conflict to approach him so that we could talk. Still, it wasn't working. Nothing worked, except (I soon learned), occasionally during our walks or hikes together. During those times I discovered him to be more open and responsive. Holding hands and feeling the wind or the sun against our faces were the times when I had closer access to his heart and his soul. I loved him so much and I didn't want to lose him (or myself), but I knew our marriage was headed for the rocks if something didn't change our direction.

73

Something did.

We shared a common computer and e-mail address. One day I noticed that he deleted his e-mail the moment I walked into the room. I didn't say anything, but when it happened a few more times, I went into our deleted e-mail files and found letters he had been writing to a Russian woman in California. A friend. "Call near midnight on Wednesday," he told her in the e-mail. "She won't hear the phone and we can talk then. Things are not good here."

I felt like I had been hit by a Russian tank. *Oh, God.*

I didn't sleep that night, and don't know how I made it through the next day, but I did. It took every ounce of strength to keep from putting dynamite instead of sandwiches in his lunchbox before he left for work. It took even more strength to lie down beside him in our bed that night and let him kiss me goodnight.

Later I got up to go to the bathroom then brought the portable phone into the bedroom and quietly set it down beside me on the bedside table.

Not long after that (when he must have thought I was asleep?) he got up and took it back to the living room.

My whole body throbbed as we played our little twisted, pathetic game of Russian Roulette. *Oh, God . . . GOD! Don't let that phone ring. Don't let this happen!*

But, just before midnight the call came. When he realized I was awake (hello?) he insisted that I go back to sleep, assuring me he would get it.

"No," I sat up and drew the covers back. "I'll get it."

"No, I shall answer it," he called over his shoulder, walking out of the bedroom. He almost missed the call, answering on the last ring.

Even if I had wanted, I couldn't have gained anything by listening in to the conversation because, of course, they were speaking in Russian. *Valentin! Valentin!* I cried into my pillow, fighting a wild, surging tide of emotion. *How dare you! How DARE you!*

After the conversation ended, he came into the bedroom. "That was my good friend P'yotr and Svetlana from San Pedro," he said cheerfully. "We had a nice chat."

At midnight? *Sure . . .*

I wanted to ask him why his friends would call at midnight, but I already knew. Besides, I couldn't have said

anything that night or the next day because fear and anger and pain clogged every vein and pore in my body. I rolled over and buried my face in my pillow once more. *God, help me,* I cried silently through the long sleepless night. *Please help me. I don't know what to do . . .*

Val left for work early the next morning. I let him fix his own stupid beets and carrots and oatmeal. After he had gone, I walked into the kitchen and put on the coffee, then walked into my office to check the e-mail. The telephone answering machine was blinking with a message. I hit PLAY and almost fell over backwards, listening to my husband and another woman conversing in their own language. *I can't believe this . . .*

A stroke of Fate?

*Fatal Fate, Mr. Gudkov,* I said between gritted teeth as I disengaged the tape, grabbed the mini tape recorder and hurried to have the conversation translated. The conversation was between Val and a woman. P'yotr (surprise) must have been sleeping. In spite of everything that had been going on, I had never once believed Val had been unfaithful but now, my insecurity morphed into green-eyed fury. The pavement on the road blurred through angry, crushing tears as I drove to a Russian acquaintance who translated every word.

"They are not lovers," she said, handing me her handwritten copy of the conversation, "but he is not worthy of you. You would be wise to forget him."

I returned home to Cider and the tears that would not stop. I knew our relationship was over. His unkind words about me, my aging, my family, his reason for marrying me and his unhappy life with me were among the most painful experiences I had ever faced. How could he say such things about me and my family to this woman, and how dare she suggest she could have found someone much younger and better for him? How cruel! How dis-honest!

I had believed Val loved my family, especially my grandson Brooks who was adopted from an orphanage in the Ukraine. I felt sure they had a special bond. My daughter and her husband brought this precious child home to a family of six sisters in spite of many serious

health issues including a heart defect, eye problems and hepatitis. Our family loved him. Valentin loved him! How could he speak to this woman about all of us in such a derogatory way?

When Val returned that evening he only had to see my red, swollen face and tear-smudged cheeks to know something was terribly wrong.

I handed him the piece of paper with every word of his conversation translated in English. "I will file for the divorce on Monday," I said, getting up and walking away. "Make plans to leave."

"Jany," he said that night, coming into the bedroom and sitting down on the bed next to me, "I am so sorry. I did not mean the things I said."

"Then why did you say them?" I wanted to scream.

"I have been unhappy. My words to Svetlana were as boasting. To make me better. To help me feel better. Can you understand this?" He took my hand.

No, I didn't. And I didn't want to talk anymore. I didn't want to hold his hand. "It's over, Val," I said, drawing my hand away. "If you ever marry an American woman again I hope you'll learn that in our country it's better to go to one's own wife or a counselor with honest words, than another woman waiting on the sidelines to fluff your . . ." I couldn't finish. "Have you been saying these same cruel things to our other Russian friends, too?"

"No."

But I didn't believe it. I didn't believe him. I turned away and he got up and walked out of the bedroom.

"Please forgive me, Jany," he said from the doorway.

I rolled over and buried my head in my pillow and my heart in the cold winter of my soul.

*3 November, 1999*

I filed for the divorce and we prepared the immigration withdrawal papers as he began to pack his belongings. Val chose not to stay in the United States but rather to return to Russia and his family. He didn't contest the divorce and wanted nothing except the wind chimes to take back to the village garden. Even our little

dog knew everything had changed. Cider would miss him. They had become fast friends.

We cried and talked and shared the marriage bed during our last days together, grasping for some semblance of closure, trying to keep fragments of the love that, at least for me, had always been there beneath the pain, confusion and betrayal. He was prepared to leave when the divorce was final and the visa expired. Immigration would notify him and then it would be over.

Yet, would it ever be over?

*What happened?* Didn't he love me? Were my gut feelings telling me that, and I was just too blind to see it?

I tried so hard to understand how the tragic, subtle changes crept like molten lava down the face of my world, my heart. What had gone wrong? Was it just too hard for him to make the connection between his dreams and the reality? Were the problems rooted in psychological issues that had been part of his culture or upbringing, holding him back from bonding and loving another woman? Or was I simply too old, too unattractive for him when he saw me for the first time at the airport? Did the photographs I'd mailed (of course I had sent the most flattering ones) scarcely resemble the woman he faced that day? Or, had he only married me to get into the country, as he told Svetlana on the phone? If that were true, why didn't he apply to stay in the United States instead of returning to Russia? *Oh, God. This hurts so much!*

Still, as painful as it was, I was thankful to know the truth and believed this *accidental* recording was no accident—no haphazard stroke of Fate.

In my loneliness and confusion and pain, I felt myself backing up, locking up, struggling for air; struggling to get back the woman I had been losing. Yet he had given me so much. Valentin drew me, and the tender waves of his passion and sweetness were as night visitors—brief and hazy, yet powerful. The day realities were disconcerting and confused me. I simply touched the fragments of this vital, passionate man and that sweetness continued to draw and hold me, continued to remind me that no matter what happened, I would never be the same.

*What happened? And why?* Were Valentin and I just one more cross-cultural relationship dumped into the

trash bins of statistics? A Russian man married to an American woman said; "Psychologically it's not easy for a former Soviet citizen to become an American. I don't even know if it's possible."[9]

I guess for Valentin, it wasn't.

On December 29th, 1999 we drove to the Seattle-Tacoma International Airport and said goodbye. There were no words, only tears, as we held each other. I wondered if I would ever see him again.

I watched the jet soar into the gray clouds and carry my dreams away, carry this man back into his world. *Go in peace, Valentin Gudkov. Return to the village and hang up the wind chimes and maybe they'll remind you of me now and then . . .*

*Goodbye.*

The days became weeks and the nights stretched beyond the midnight sun and fell like dead things upon the wasteland of my heart. I am lying in pieces and all the King's horses and all the King's men can't put Calamity back together again.

Where is the King?
*Resuscitate me please!*
But no one did.

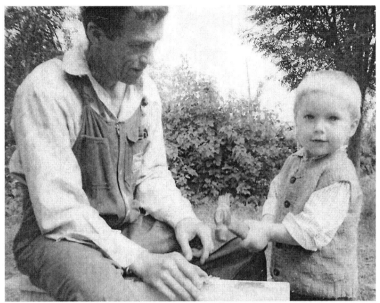
Val and his grandson—my first picture of him

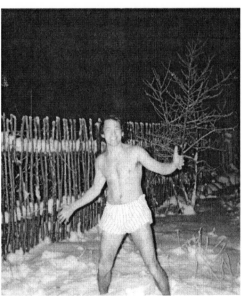
Val coming out of a sauna in Russia.
I knew I had to meet him!

Val ice sailing

Val skiing

The first formal picture I sent
to Val

Val's favorite picture before
he met me

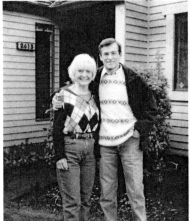
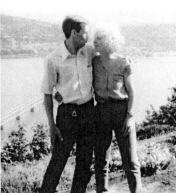

Val and me at my house
—home, sweet home

Val and me getting better
acquainted

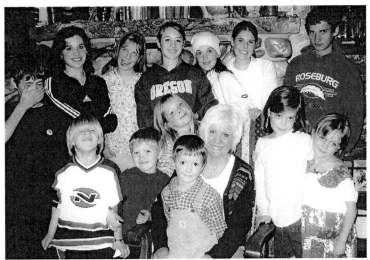

Nana (me) and my Angels. Would this scare him off?

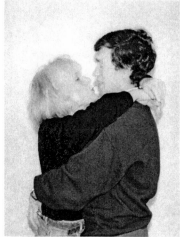

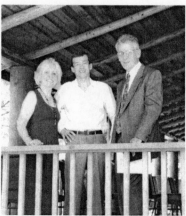

Things start to get sweeter

It's official (with my brother who married us)

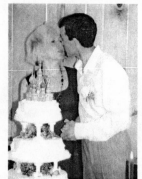

Wedding kiss

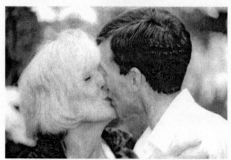

Will our dreams come true?

Celebrating by the fireplace

Honeymoon on wheels

Val and water go together

Brooks (my Russian grand-
son) and Cider

Hiking with friends

Welcome to my flat in St. Petersburg

Val's mom loves American Coffee

My new Russian mom relaxing in the flat in St. Petersburg

Val's daughter Katia, and his grandson Vadim

Celebrating with Val's friends in St. Petersburg

Welcome to Val's dacha in the village of Volochyok

The village well

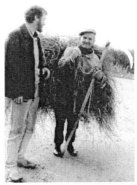

Village women with wood cart

Val chatting with a Villager

Horse plowing potatoes

Potato farmers meet an American woman for the first time

Ninety-year-old Anastasia, family friend in the village

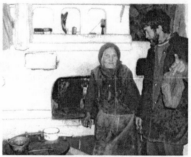

Anastasia has never seen an American before

Anastasia's vegetable garden and milk cow provide her income

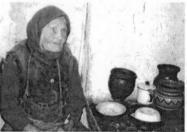

Another portrait of Anastasia

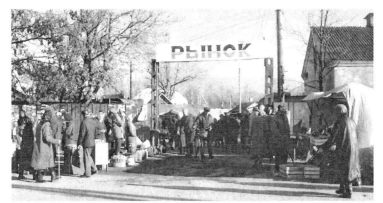

A Russian marketplace

A Russian monastery

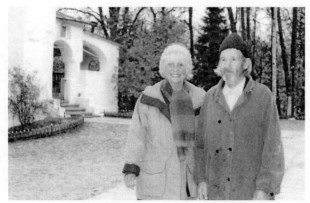

A picture of me with a monk
apprentice at the monastery

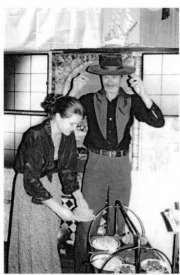

More Russian friends and
their kind hospitality

More beautiful Russian
sights

A picture of me with Val's daughter and grandson

Val and family remembrance

Tying the knot one more time

My grandchildren and memories

A new lobster experience for Cider

Our last day together at the ocean with my grandkids

2008—Val in Sochi Russia with his
daughter Dasha and his two grandchildren

# CHAPTER FIVE
## The Iron Curtain

*I found ways to forget my loneliness*
*and in the process forgot who I was.*
*Like clear water clouded*
*by the turbulence of tides,*
*fear became my guide while*
*love seemed to be locked from my heart.*
*I covered my fear with layers of armor,*
*and while I did I locked love out even more,*
*until I was afraid of love itself.*
*My shield became doing well and looking good.*
*Yet how strong could I make an eggshell!*
*I began to break,*
*and in the pieces I found who I was.*[1]
—Lee Jampolsky

What had happened to my dreams? My love? *My life?* Gloria Steinem said, "Perhaps the worst thing about suffering is that it finally hardens the hearts of those around it."[2] I didn't want my suffering to do that; not to those around me, not to me. I wouldn't.

*Dear God of the Universe, what happened?*

The days and weeks of anger and pain and soul-searching continued to throw me against the rocks.

Why hadn't the King stepped in?

*God, why don't you help me?*

*Because I have given you the tools to do it yourself.*

"What?"

Had I heard a voice or was that just me? My thoughts hit the skids, crashing into my well-ordered (pea-brained?) life framework. No matter how strong and wise (?) I had become, in the very deepest—softest, wimpiest—place, I wanted to be rescued. It was the Fairytale Principle, of course. *Or the God Principle?* Whatever was happening, all

the King's horses and all the King's men (Prince Charming, the Little Emperor, the God of the Universe) weren't putting Calamity back together again.

*. . . I have given you the tools to do it yourself.*
"Oh, God . . ."
*Do it myself? Do what? What am I supposed to do? I am breaking into little pieces and you are telling me to take care of this myself?*

*You covered your fear with layers of armor*
*So what was I supposed to do, God? Throw kisses across the borscht?*

*. . . and while you did, you locked love out even more*
*Seems a little safer to me.*

*. . . until you were afraid of love itself*
*Darn right.*
Angry, I got up and took my little dog for a walk. She barked with joy as I attached her leash and headed down the woods path.
"*I LOVE MY DOG!*" I screamed silently. "*And my family! And friends!*" But at that moment, I wasn't so sure about anything else. I hated what had just happened to me. Hated it! I failed again, didn't I? *"Thanks, God! Thanks for letting all this crap hit the fan and make me look like a fool! Plus my heart hurts, and I feel OLD!"*
Well, I could move on and I would. I wiped my eyes and got up, telling my family and friends (with a tight little smile), that I would be fine. Just fine.
I knew how to do that.

*My shield became doing well and looking good.*
*Darn right again.*

*Yet how strong could I make an eggshell!*
*Calamity Damity sat on the wall, Calamity Damity had a great fall . . .*

*I began to break,*
*Yup. And it's not the first time, either.*

94

*. . . And in the pieces, I found who I was.*

I am groveling around trying to pick up the pieces when a letter arrives from St. Petersburg.

*26 January, 2000 St. Petersburg, Russia*

*Hello my Dearest Jany! I am missing you so much. I was sick for a week, but now I am okay. How is the family? It's so nice that we are alive, although such an amazing last year. I have had beautiful time with you and your family. Now it's time to take care about our health. The knee surgery is behind, then I'm going to check my stomach and skin. I'm glad that you work at your health too. Soon we will be bouncing and young as Cider is.*

*Here is cold and snowy, about 4 F outside and 66 F in our apartment. I wear warm sports suit and wool socks. I hope it will be warmer soon. I don't drive but use public transport in such weather. Honey, be very careful on icy road—don't hurry. I'm so sorry about Brooks but I'm sure God will help him and Julie. Best wishes to your family and especially, Mom. I miss and love you and them. Give some snack to Cider from me. You are close beside me every moment. Write me as often as you can. I hug and kiss you. Your Valentin*

*I have had a beautiful time with you and your family.*

I sat down with the letter and cried. The *beautiful time* ended in divorce.

Then he got sick.

*You stubborn Russian, I won't be there for you with mustard or any other stupid thing!* I yelled at the blank wall. *Stupid mustard and sour milk and dry bread! I can't even figure out how to pick up the pieces of my own life, and now you tell me you've been sick and you're hugging me and talking about the beautiful time you had with me and my family? Puhleeese!*

At that moment I wanted to burn his letter and every single memory. Now I even wondered if it was wise to stay in touch as we had agreed.

I didn't burn his letter, but knew I had best mop up my tears, pick up the pieces and move on. But forgiveness

loomed and I knew I had to deal with it. *You're going to have to help me with this one, God, because if you don't, I'm cabbage soup.*

*God? Will you help me, please?*

*I have given you the tools to do it yourself.*

This time the words didn't sink like rocks in the Finnish Gulf.

*The tools?*

*. . . do it yourself.*

*Okaay . . .*

I picked up a pen (one of the tools?) and began to write to Valentin. It was a hard letter to write, maybe one of the most difficult I have ever written. I wanted him to know that above all else, I loved and forgave him (that wasn't easy) and that I was deeply sorry for the way everything ended. (Lord God, I was so sorry we had crashed and burned.) I told him that I had sold the motor home (sad), that Cider missed him and that I was doing okay (yeah, sure). I can't remember a lot of what I said because those days and weeks were stained with sadness and tears and a lot of looking inside myself. I didn't always like what I saw.

*1 February, 2000*

*Dear Jany. I'm very glad to share the life of your family and you through the ocean. I'm so sad about our faithful Loaf—she gave us a lot of fun and happiness. Let's be joyful and patient to each other. We can do it and become happier and stronger. We will work for this and have to help each other, to be more flexible and tolerable, and not indifferent. Let us be Hot or Cold, but not Silent. Honey, would you inform me in the future about my faults more, but not in gentle voice, but concretely. It's not easy to look below the surface of our consciousness as sometimes it is ghastly and unpleasant, but we have to do that. I'm a man and this is very hard for me. I appreciate your care about me, about us. We can do it, always stay honest to each other and study sharing our lives, our feelings. Sorry for troubles and pain I have done to you. I have to do a lot of*

*hard work to be worthy of you, Honey, but I will try. I respect you. You raised so great children and achieved so high spiritual level. I love you Jany. Thank you for your sincere and honest letter. It is helpful for me. You expressed and recorded many of my thoughts and feelings which I could not express to you (and, maybe to me, too).*

*I have read a lot about the importance of Forgiveness, but only after your letter I understand clearly its meaning. Last fortnight I prayed and asked God to forgive me for hurting other persons, and that I forgive those who have troubled me. Then I will do the next step, will ask their forgiveness and give them mine. It's not easy, but I will do it. Honey, now I feel more better and free. Something has gone from me, something heavy and gloomy, but not all. It is the beginning of escape from heavy "stones." Thank you, my Dear Calamity.*

*Kiska, I understand how it was difficult for you to write all that. You are very courageous woman—the real daughter of the Wild West. Our connections are so important for me and they are the Reality of our life, too. I am not a writer, but I want to become a true friend and partner of the real writer—dearest Calamity. I love and want YOU.*

*With love and kisses, Val*

*Kiss my lovely Rachel and give all the family my love. Say hello to Dad. Maybe somebody will continue my job in his garden. The spring is so soon. Keep writing books. Soon you will be famous, Honey, but I love you unfamous too. I kiss you.*

I held his letter and wept, trying to grasp everything he said to me, to himself. Fragile and wounded, I still walked in grief. It was a terrible time for me and although I realized it must be hard for him as well, I couldn't understand why his vulnerability and tenderness hadn't embraced me during our days together? *Why now, you stubborn, Russian?* My questions and anger throbbed against my soul.

How did he move into the role of Commander-in-chief so quickly, showing such impatience and making so many demands? Was this simply cultural or a character issue? I

remembered his words in one letter; *I am too demanding with Mom and my kids. One of my demerits.*

Huge demerit. Why hadn't I paid attention? I felt like the KGB had moved into my house and set up headquarters. Only in bed at night after his arms gathered me close, could I find fragments of this tender man who had written such letters of love.

During the day battles, my knee-jerk response was to withdraw, and I did. For me it was futile to stand against an iron curtain in our private cold war. I hated the arguments and dishonesty. Concrete? I just wanted to run and by the time I did get a counselor, it was too late for the marriage.

*14 February, 2000*

*Hello Jany! Congratulations in our lovely Valentine Day. I love you and your family—it's my family too. Say hello to everybody, especially to lovely granddaughter Michal. Happy Birthday to her and a lot of good time with the best Nana in the world. I will be with you. I'm not cozy without you, Sweety. I pray for Brooks' health every morning. Best wishes to Julie and Skip. I'm so glad for Blake and Patty and hope sweet Rachel will have a handsome brother or a beautiful sister. God help them.*

*I am missing you and Cider. You are close to me. I'm missing you and your family a lot. I think that we have hastened too much with our divorce.*

*Take care Kiska. I feel your love*

*Yesterday I was in the church and prayed for all of us. I miss you every moment. My love becomes deeper. Do you feel it? The sunset was so beautiful on Sunday. It reminded me our last sunset on the beach.*

I remember our last evening together. We walked on the beach as the sun dropped behind the water. It was, in a way, symbolic. The water had always drawn us. And separated us.

*15 March, 2000*

*Good Morning, Kiska. I know that nobody (except Mom)
has ever loved me as you. You didn't trust me and I
understand this. I was so wrong and the initiator of our
formal divorce. I am SORRY. I hug, kiss and touch you with
love. Yours, Val*

I read the letter and cried. Again. At this rate, I might
flood every river and creek in the western United States.
Hastened with our divorce? What else would a woman
have done? After reading more of *Wedded Strangers*,
though, I learned that a Russian woman might have done
differently. The Russian wife will not be criticized for
leaving a husband who beats her or who is a drunkard,
but a man who is unfaithful does not give her a valid
reason for getting a divorce. Valentin didn't lay a hand on
me, wasn't an alcoholic, and if there was adultery, it was
not sexual, but rather emotional as he sought solace and
deeper connections with other women. Adultery (by any
label) wasn't grounds for a Russian woman to divorce her
husband!

*Calamity,* I said silently, *you are not and never will be
a Russian woman.* And yet, there were other reasons why I
*hastened* with that divorce. Perhaps if I hadn't had some
issues with immigration, I might have considered a
separation, rather than a divorce. But I dared not. If we
had separated, according to the terms of the visa, I was
financially responsible for Valentin for three years if he
remained in the country (divorced, separated or other-
wise), and I couldn't take that financial risk because I had
lost my former husband's social security when I married
Valentin. Unfortunately, my financial survival became a
determining factor in my decision.

*11 April, 2000*

*Hello Kiska! I have been in the village for three days
and pruned the apple trees and bushes. Mom has cleaned
the house and gathered old leaves in the garden. Although
the weather was very cold, I relaxed and enjoyed fresh air
and country nature. I miss you and our intimacy. Now I feel*

*and know what it is. Thank you for this new feeling for my life. With tender love, Val.*

He called and invited me to visit him and the family and meet some of his friends in St. Petersburg, and also to travel with him to their country house and see some of the less traveled sights in the Russian countryside. We talked about this and I finally agreed to come for a two-week visit. We had left so many things hanging. Maybe by talking things over and getting more closure, we could both move on with our lives.

*12 April, 2000*

*It was good talking with you, Kiska. I want you to come as soon as you can! October is usually not bad season to visit but it is not enough to stay here only two weeks. I want you to be here not less than two months or forever! I love you and hope this can happen for us!*

*I'm not sure about the forever, Val.* A few weeks might be important for us, though. We needed to talk. And yes, I think we needed to hold each other.

*18 April, 2000*

*I have had the promotion, my job became more complicated, but Vladimir helps me a lot. The weather is warmer. Irina and Varia are visiting and came and were with me in the ballet. I am missing you Jany. I know that I have lost the best wife and friend, and real intimacy. I want to be with you again. I love you and want to be near you.*

I wanted it, too, but I just didn't know if we could pull this off one more time.

*29 April, 2000*

*Hello my Dearest! I met Vadim and Katia today. Vadim did not recognize me because of my very short haircut. I did it yesterday. Where are you—the best hairdresser in my life? Mom is happy now. They all send you hugs and*

*kisses, the same from me Wild Kiska. We will be in the village for four days. I have to do plenty of job in the garden to prepare for Mom's season. Our Easter will be on Sunday. Say my blessing to your family. How is Dad? I am with you, Jany. Every moment.*

My 96-year-old father wasn't doing so well. His bone cancer began to spread and even with the help of the caregivers, I didn't know how much longer he could stay in his little country house on five acres near BZ Corner. He vowed that it would be over his dead body if anyone dared try to put him in a nursing home, but after one more trip to the hospital, there was no other choice. Thankfully, all of us lived to tell the story. Surprisingly, it turned out that Dad liked (loved) most of the nurses and nurses aides at the care center and this saved all of us. At least for a while.

*30 April, 2000*

*Today is Orthodox Easter. Our family is in the village in our summer house. The house is very simple without water supply and a lavatory outside. Because of that Mom doesn't want to live in it when the weather is cold. Now the weather is sunny, but very windy and cold, only about 40F. I like to rest over here, but not together with Mom, especially now after living with you. Sweetie, you became to me closer than Mom and my family, you became and are a part of me. It is a pity that I have understood this so late. I lost a real friend and the best wife for me—you, Honey. I love you, Kiska and you are the closest person for me in our world. I am not so sensitive as you. I did not feel real love for many years, but I know that we are created for each other and that you love me. It is a great feeling, but I am very sad I am so far from you. I am missing you every day and night. I need you, Jany. Let's try to construct our close relationship once more. I am not a womanizer, I want only you. I hope you will think about this and your special, kind heart helps you. The life is so short.*

*PS I am sorry that Dad must leave his cozy house.*

I wrote Val a long letter during the hours and days beside my father's bedside. While Dad slept, I had time to think and to write the man I still loved, the man who wanted to try to make our marriage work once more. Could he truly love and adapt to the American wife and life in our country again? Could he overcome cultural barriers and actually let his wife become his partner and friend? Could he open up and share his feelings, especially when things went wrong—and could I? And what about the dishonesty? Could he defeat that inner demon and could I learn to trust him again? There was so much to consider, but Val was right about one thing; life was so short.

And I wasn't getting any younger.

*19 May, 2000*

*I received your letter two days ago. Thank you—Jany for so hard, but true words. I am the dishonest man and this is not only my trouble. It is a trouble of many persons (not all) in our country because for many years our Soviet idea was untruthful in all spheres of human being. My grandparents were very honest and faithful people, but they were born before our revolution. My father could lie sometimes. I can too. He was a good, joyful man and loved life, but he was a product of our social society, the same as I. But I wanted and want to be honest in all, and you are helping me in that with your very painful but true words. I hate my dishonest, but in my country it is very hard to be honest in the atmosphere of great lies and instability. Many people left the country because of that. Russian traditions of religious, honest life were crashed and transformed during more than 70 years. I dreamed that near you, who really loved me, I could be changed. I tried, but I could not do it in so short period of time. You tried to help me, but I was impatient. I am who I am, but I sincerely want to change myself. Help me, Jany. I need a counselor as all our society. It is very hard to get one, because we did not have them for many years at all. It was not important here. The only way is to work hard myself with your help. I feel your love, Honey, and I am sure you will help me.*

*Now I sit in our garden with Mom and Vadim. It is 8 p.m., Saturday. It is a nice warm evening, the orchard is in full bloom, the sky is pink-blue. We came here today at noon. I have constructed two small greenhouses for tomatoes and cucumbers, pruned some cherry trees. I am tired, but it is okay. I tried to swim after my working day, but the water was cold in the river and I did not. Mom and Vadim will stay here till September and I will be alone in the city, work hard and visit them each fortnight.*

*I am waiting for your visit in October. I will send you an invitation in June. I love my Kiska stronger. Our wind chimes remind me of you every morning and night. My arms are around you, Sweetie. I am with you.*

I sent a quick e-mail explaining that I must write later, that I am hurrying to my father because he has been rushed to the hospital and might be dying. The trip will take three hours. *Wait for me, Dad . . .*

*25 May, 2000*

*Hello Jany! I hope Dad will pass peacefully. I love him. He was very good with his Russian son. It is sad that I am not with you, Kiska, in this trouble. Be strong. With tender hugs. Valentin*

I stayed with friends near the nursing home across the river in Hood River, Oregon so that I could be closer to my father and care for him in the small ways that sometimes only a daughter can do. My three siblings all live in different parts of the country and couldn't be with him as often as I. Everyone at the care center got to know me and I got to know and appreciate them. I was exhausted, but watched as Dad gradually gained strength and began to get back to his feisty self once more. He's bossing me around again. I'm so glad he's feeling better!

*13 June, 2000*

*Hello my Jany! Happy Anniversary to United States! In spite of some bad moments, the year was great. I have gotten the best wife and friend. I am with you and your*

*family and so glad Dad is better. Happy birthday to Rachel.*
*I love you.*

A year? Has it really been a year already? During these days, weeks and months, I had so much time to think. I thought about us and what went wrong and wondered if he had been changing, truly changing in the ways that would keep us from spiraling back downward as before. I thought about myself and my attitudes and reactions, too, determining to make some changes I needed to make.

Jill Boldt Taylor, Ph.D. in her book *My Stroke of Insight,* talks about her recovery after her stroke and brain surgery. "Before the stroke, I believed I was a product of this brain and that I had minimal say about how I felt or what I thought. Since the hemorrhage, my eyes have been opened to how much choice I actually have about what goes on between my ears."[3]

*20 June, 2000*

*Good morning, Kiska. I am okay with my body, but so alone spiritually without you. I have lost so much. I want we will be together again.*

*Oh Val, I want for us to be together again too, yet I'm not sure. I'm just not sure.* I knew I had some important choices to make.

*June 29, 2000*

*Kiska, I am feeling so lonely without you and Cider, though I am surrounded by my schoolmates, friends and co-workers. As to the difficulties for some of your friends to accept what had happened with us—the truth is better than the lie. Now I know it definitely, as I know I love you stronger and want to share everything with you. Best wishes to your family (Bob and Laurie especially). I hope they forgive me.*

It was difficult to face everyone with the truth. Painful. I had to try to make sense of it myself first. It took me

time and a lot of soul-searching to find words for the chaos and confusion that muddied my days and blackened my nights. Some of my family grew deeply attached to him and this break-up and the painful truth as to why it happened was especially hard for them. I wrote and told Val that yes, my daughter and her husband did forgive him. They loved him. A few friends and family didn't, but most were keeping their own counsel (biting their tongues) and not troubling me with advice and warnings.

*4 July, 2000*

*Today is your country celebration day and the birthday of my father. He passed away ten years ago. The weekend was very peaceful for me. I worked a little bit, swam, fished with your rod and Blake's hooks and slept. I caught only one small perth for neighbour's red cat. The orchard will produce well. It is a pity that nobody can care for Dad's orchard except me. I must be with you, Jany, spiritually and for all these practical acts. Your children are so busy and friends are not near you. You need me and I need you! I changed because your love has changed me.*

*Don't forget to water the thirsty grass in the morning, not at night. You can put some ash from the fireplace under the roses and pick up the insects from the leaves. My best wishes to your family. I hope they remember me sometimes not from bad side. I love and want you, Kiska.*

*I changed because your love has changed me.* Oh Val, I'm not sure, but I want to believe that. My soul wept quietly during those days as I wavered between trust and doubts, hope and despair.

I wrote him from the Columbia River Gorge where I set up a booth of Dad's photography at the *Gorge Games,* a world class event where outdoor adventure athletes came from all over the world to compete in river rafting, wind surfing, mountain biking, kayak racing, kite boarding and so much more. The Columbia River with its picturesque gorge framed the river-gouged border between Washington and Oregon. Dad continued to gain strength and although he wanted so much to be in the booth with

me and his photographs, he couldn't. I visited him in the nursing home each day, giving him the day-by-day reports about the fascinating visitors and events and which photographs we sold and to whom. Even NBC News had come to capture this exciting event. Dad loved knowing that his photography was appreciated and living on. And Val enjoyed hearing about the day-to-day events as well.

*15 July, 2000*

*Hello my Dearest. I have had a big pressure at my job and now have a problem with the stomach. But I am alive and feel your love and care and because of that I am happy and healthy spiritually. Thank God and my kind Kiska. It rains every day here now. I will drive to the village this weekend and won't work, only drink milk, sleep and walk. I miss you so much. I love you. Lonely Russian*

I missed him, too. The truth was that I still loved him deeply and cared that he wasn't as healthy as he should be, yet my head continued to throw up wise, careful warnings. *Stay cool and don't do anything stupid, Calamity.*

I called and told him that I had gotten the invitation and would go to the consulate to begin the process of getting my paperwork in order. Thankfully, he was feeling much better by the time I reached him.

*21 July, 2000*

*Hello Kiska! It was so nice to hear your voice last night. Yesterday was a wonderful day. I went to my doctor in the morning and found a small silver cross in the street. After the doctor I went to the church and asked the priest-father Michael what that event meant and whether I might wear the cross. He answered that it was a good God's sign and I might wear it. Then he sanctified the cross with the saint water. It is my second body cross. I had presented my first cross (the gold one) to Vadim when he was baptized. Let me try to explain our religious difference. I was grown up in the family of the atheists and all my friends were the same. I baptized only when I was 44 years old. I had never read the Bible before. Then I read the New Testament, but many*

106

*things I didn't understand and nobody could help me explain the meaning. I began to visit churches on working days after the job, never on weekends. The weekends were for pleasure, not for the spiritual work. For me it was a real <u>hard</u> spiritual work because I didn't do it from my childhood as you did and do and the rules and services of our Orthodox church are so complicated that it was so hard to understand them.*

*The second part of the day was very good. I made a good job in the office, relaxed in the sauna and, after all, got a call from you. I believe it was really a God's sign. Nice day!*

*Now I am going to bed to watch and touch you on my dream. Good night, Sweetie.*

I slipped his letter back in the envelope and thought about his words. Life in Russia as a young communist (and atheist) had been nothing like growing up in this country. His honest appraisal and candid expressions of his faith and his doubts continued to amaze me. I think we both want to learn and understand more. Perhaps together. A faint caution light continued to blink in the back of my head (between my ears), but I didn't notice it as often anymore.

*29 August, 2000*

*I have missed our connection. I had to work for 12 hours a day last week, and will do the same this week, too. I worked till 8 p.m. on Saturday, then went to the village. On Sunday I dug the potatoes, then parted Vadim to Novgorod to the train to Moscow, then back to the city at midnight and on Monday morning again a hard work. I am okay, though very tired.*

He is busy in the village after a long week at work and we aren't connecting as often as we'd like. There are no computers in the village and even if there were, he would be too busy with the end-of-summer harvest from the garden and orchard. We connected by phone during his work week in St. Petersburg.

*6 September, 2000* (The visa news)

> *Hello my Kiska! It was great and pleasant news to get your call. I saw the very pleasant colored dream before your call. I had not seen such for so long time. I was in your house and saw a field full of flowers through the window. There were not the fence and houses of your neighbors, only Cider was walking and barking in the grass. Your call did interrupt such beautiful movies, but the news was the greatest one. God granted us visa, Honey! Thank you God!*
>
> *I'm okay and healthy. The new job is not hard, it is in the office. It is a private trade house of my old comrade. I begin my work at 10 a.m. and finish at 5 p.m. I reach my house usually at 6:30 p.m. Tomorrow I will go to the village and come back with Mom on Sunday evening. Her summer season is over. It was very warm one. I'm sure she likes it. God bless her. I close now. It was a nice day. You are close to me. I love you. I want you to take care about yourself. I pray for you every day. I send you my love through the ocean. I feel your love and spiritual energy. I kiss you many times.*

His letters and charming, colorful descriptions of dreams and life melted me. I felt his love and spiritual energy through them. And his kisses. *Here I go again . . .*

*16 September, 2000*

> *Happy Birthday Jany! I wish you many, many years in peace and strong health. I love you, kiss and hug you many times. God bless you.*

Val and I are now discussing his connections with Svetlana because they are still communicating. It was not an issue for me until Val and I began to establish more contact and make plans to see each other and perhaps be together again.

I had forgiven Val and this woman who was a university friend of many years. I told him that if we do get back together again, his communication with her would make me uncomfortable. Right or wrong, it's how I felt. Forgiveness didn't mean that what happened was okay (it

wasn't), it just meant I was going to let it go and move on. Moving on didn't mean it was gone with the wind. Val wanted me to *forgive and forget;* and while forgiving was possible, forgetting wasn't, as long as I still had functioning gray matter between my ears. We all learn from these past experiences and some of those lessons can make us wiser and protect us in the future. I was still in the process of healing, of getting the pieces of my own life back together. Maybe later I would feel differently about having her in the picture. I didn't know. For now it was enough getting him back in the picture and the two of us functioning again.

*19 September, 2000*

> *I am very upset that I have hurt you again by keeping communications with Svetlana. She and her husband have been friends for over thirty years, so this is difficult for me. I am sorry and know I am responsible for our problems, not you. I am a man and sometimes it is so difficult to me to understand the woman's attitude about these things, but I try. I was dishonest but I want to communicate with you honestly and clearly. I decided not to have connections with her. Time can heal our souls and, maybe one day you forgive me really and the hurt in your heart and mind will be gone. I was dishonest sometimes in my life according to the reality in my country, but never unfaithful to my ex-wives, friends or other persons. I was not and I am not a womanizer. I really don't want to offend you once more. I hope God helps us. I look forward to meeting you here in October. I love you.*
> *Bad Boy.*

"I'm coming," I wrote back, still teetering on the edge of whether this was the right thing to do, or a mistake. Could time, forgiveness and hard work really heal our souls and give the marriage a chance one more time? I still loved him—missed him, but I didn't want to be walking beneath any more shadows of dishonesty and silence. We talked a little more on the phone and by e-mail. His decision to end his communication with Svetlana was important for me. I knew we still had so much to talk

about and work through, but I believed we might be able to do it this time.

A few days later I e-mailed him about my grandson, Brooks, and more health issues that faced this little boy and our family. The doctors were concerned about the hole in his heart and discussed the risky surgery with my daughter and her husband.

*25 September, 2000*

*Good morning Kiska. Thank you for the e-mail. I am very upset about Brooks' heart problem. Say my hello to Julie, Skip and their family. I pray for them. I didn't close the summer house for winter because we will visit it and some beautiful country and villages near there. You need to bring a rubber boots. I love and want good calm girl, and a Calamity one.*

*2 October, 2000*

*Hi Jany, I am all right and weather is fine. The waterproof leather boots are okay, but you are the main. I need only YOU. Remind me your arrival schedule. Sorry for a short note. I am very busy before the vacation. I love, hug and kiss you many times.*

# CHAPTER SIX
## The Shchi Hits the Fan
### (Shchi—Russian cabbage soup)

We unloaded the car into a log house that felt as cold and inviting as a cave. A fence encircled the half-acre surrounding the dacha where the last of the garden harvest lingered. I pulled a wool cap over my blonde hair and gazed beyond the apple trees creaking in the wind where the outhouse stood rigid against the gray October sky. *Get ready, Calamity.*

On October 12th, 2000, at 3:30 in the afternoon, my flight landed in St. Petersburg, Russia. Now sporting a beard, Val met me at the airport with roses and smiles.

"Kiska!" He rushed toward me and drew me into his arms, plying me with kisses. I drew back and smiled, reeling from the kisses and the exhaustion of the 19-hour flight. It *was* wonderful to see him again.

His friend Victor stepped forward, welcoming me to St. Petersburg with a bouquet of carnations and a warm Russian hug. "Welcome to our city, Ja nett!" he said, pronouncing my name with a dramatic, charming accent. Victor and his wife owned a small travel business, helping us obtain the visa and make arrangements for our travel. He would be driving us back to the flat.

Victor dropped us off in the outskirts of St. Petersburg where high-rise buildings sprawled for miles. The iron-grated elevator rattled and clanged up to the seventh floor of Val's flat where his mom waited for the doorbell, unlocking first the wooden, then the steel door of their apartment.

Nadia welcomed me into their home that literally shined with fresh wax, warmth and cleanliness. The bond between his mother and me was immediate. Although I had to depend on Val as my interpreter, certain connec-

tions needed no words and those connections were strong from the start. Her vivid blue eyes were so like her son's, but other than that I saw no resemblance, except that they both had classic good looks. His chestnut brown hair was in stark contrast to her once-blonde hair now tinged with gray, and she was as robust as he was slim.

After a delicious meal of pork and mushrooms and gifts exchanged, she excused herself and left Val and me to reconnect once more. It was so good to feel his arms gathering me up again. It had been almost a year since we said our tearful goodbye in Seattle. That night and over the next few weeks, we began our uncertain journey toward each other once more. Could we find our way?

The following morning we said goodbye to Mom, loaded Val's compact car with some clothing and food, and began our 120-mile trip through towns and villages to their dacha in the village of Volochyok. Birch, oak, pine, larch, shrubs and bushes covered the rolling hills where villages were clustered like vestiges from the past.

"The country houses are called *dachnie domiks*," he explained as we drove the winding, two-lane road through the countryside. Most were constructed of logs with wooden siding.

I inquired about the older women—*babushkas*—sitting along the roadside, selling their handiwork and vegetables from the gardens or orchards. "Some also sell pies and pastries which are very tasteful," he told me. "We call them *pirogi* and *pirozhki*."

We stopped and bought some, and Val was right—they were delicious. We made a few more roadside stops where I bought a pair of hand-knit mittens, scarves, warm socks; beautifully handcrafted souvenirs for my friends and family, and for myself. The exchange of money for goods helped many support themselves or sometimes helped finance a child or grandchild's education.

Val and I carried a handy stash of toilet paper for our little side excursions into the woods and bushes, since rest stops and public restrooms were nonexistent. Just before we reached our destination four hours later, we stopped at a rock outcropping and filled our jugs with fresh spring water.

"We shall need this since there is no running water in the country house."

*No running water?* I paused and drew a deep breath, then picked up two jugs and carried them back to the car. *Okay. I may also be looking at the possibility of a Honey Bucket. Or worse.*

"There is a village well, but this water is more perfect and pure."

I focused my thoughts on those amazing Russian women sitting alongside the road *smiling* and realized that if most of them could go without running water and indoor plumbing for a lifetime, why couldn't I do it for a week? *I don't think I could be a babushka for longer than a week, though.*

"We do have electricity," he said pleasantly.

"Oh, good." I smiled over the mounds of jugs, luggage and toilet paper as though it didn't matter. But it did, of course. I was thrilled that we would, at least, have heat in the cottage. *I can do this.* We drove on through the cloudy countryside until we reached the village of Volochyok, which unfortunately, welcomed Calamity Jan and the Russian with a power outage.

"Sorry, Kiska. This happens a lot in the villages. It comes back on sooner or later."

*Oh, great. Like when? Next week?*

I think he sensed my misgivings. He leaned over and kissed me, which at the moment, didn't send a little frisson of anything racing through my veins.

We unloaded the car into a log house that felt as cold and inviting as a cave. A fence encircled the half-acre surrounding the cottage where the last of the garden harvest lingered. I pulled a wool cap over my blonde hair and gazed beyond the apple trees creaking in the wind where the outhouse stood rigid against the gray October sky. *Get ready, Calamity.*

Val parked his car in one section of the cow barn, a structure attached to the back side of most village houses. "Most of the attached cow barns are still used for livestock," he explained, showing me around the remaining extension which he had remodeled into a separate apartment for himself, constructing a fireplace and

sleeping loft to give himself privacy during the summer months spent here with his mom.

"It's so rustic," I said finally, feeling the cool wind slither through the cracks in the walls. *Like everything else around here.* I walked toward the door and opened it, staring at the clapboard building beyond the orchard.

"You're quiet, Kiska," he said.

"Oh?" I stood in the doorway, now considering optional plans for the midnight run to the Russian Honey Bucket.

"We'll take a walk and see some of the countryside and hope the power is back before we return," Val walked up and took my hand.

"Yes. Yes, that's a good idea." I think I smiled.

It was late October and it was cold. We hiked along the river, eventually crossing a primitive bridge into the next village which had also lost all power. We passed villagers returning from the fields with tools or grain slung over their shoulders. Dogs barked and wandered up the streets and small children peered and giggled from behind old sheds at the strangers in town. Thankfully, just before dark, the village came to life with windows glowing gold in the dusk.

"The power is back on in Volochyok, too!" Val said, pointing across the river where the lights of his village twinkled.

The sights were wonderful, but it felt deliciously good to warm my cold hands and feet by the portable electric heater back in the day room of the cottage. Three single beds, a rocking chair, and a small kitchen table and chairs filled the small room; lace-curtained windows accented the walls. The simple kitchen, separated from the day room by a wooden door with curtain-blankets to conserve heat, consisted of a few cupboards, primitive counter, propane stove and a sink without plumbing. Beneath the sink was a bucket which served as a catch-all drain by day, and slop bucket by night.

*At least I won't have to be stumbling around outside trying to find my way to the outhouse,* I realized. I stared at the metal pot without a seat and wondered if I could sit on it without tipping it over. *Good grief.* Of course there would be no spa bath by candlelight in Volochyok.

"Just move it back under the sink when you're finished," Valentin broke into my uneven thoughts.

"Okay. Sure."

My first dawn in the village awakened me with roosters crowing, cows mooing, dogs barking and sheep bleating. Back home, our local Neighborhood Association would be having some trouble with this since they don't even allow RV parking for more than three days. We Americans ought to have a few bales of hay, stray chickens and some cows dumped in our backyards now and then to help us get our priorities readjusted. Mine (priorities) were getting ready to hit the fan.

"The villagers take their turns leading the animals out to open pasture each day," Val explained as I watched the creatures follow the herder along the road in the front of the dacha. "They free-roam and feed until dusk when he brings them back and returns them to each gated yard."

Val told me that many of the country houses (once called Izbas) in this village have a fenced half-acre which accommodates the cow and smaller livestock, garden and orchard. I noticed that these amazing people, most of whom were permanent residents, were already up and pushing water carts to the village well or carrying loads of hay by sunrise. It was like living in another century, and all I could think about was the grim possibility that there might not be coffee or a coffee pot in this place!

"We can have a nice cup of tea," Val explained when I told him why I was rooting around in the cupboards.

*I can't believe this . . .*

"With lemon," he added pleasantly.

I left the room immediately, and it wasn't just because I needed to use the slop bucket. "A nice cup of tea with lemon just doesn't cut it," I said between gritted teeth, squatting on the cold rim of the metal pot. The coming days were going to be real test for me, but I figured if these brave Russian *babushkas* could do it, so could I. Did I have a choice?

I stood up quickly after doing the things I had to do, then walked over to the sink to wash up. *Don't be such a wimp*, I said as I picked up a container and poured some spring water over my hands, splashing some onto my face. *This could be a lot worse.* Suddenly I felt something cold

and wet splashing all over my legs and slippers. Stooping down, I realized I'd forgotten to put the slop bucket back under the sink drain. *Oh no . . .*

"Kiska!" Val called cheerfully from the other room. "Good news!"

I was on the floor looking for a mop or rags, wondering what kind of exciting news that might be. Maybe he found some mustard for our toast?

"Kiska! Jany? Are you okay?"

I walked into the day room, leaving a trail of wet slipper prints in my wake. *You're getting too old for this, Calamity.* "So, what's the good news?" I said through tight lips.

He stared down at my water-splotched robe and slippers. He knew.

We started laughing until the tears came.

Finally, I sat down at the table, wondering what might come next. This was day two in the village and I had four more weeks to go before I left Russia.

"I hadn't realized, but Mom sent a little coffee," he said, pouring some hot water into a cup and stirring in some instant coffee. "Enough for a couple of days at least. I knew you'd be pleased."

*Instant coffee?* I grabbed the cup and felt the warmth in every fiber of my being. I normally didn't drink instant coffee, but this was *so* better than nothing. *Ohhhh, dear Russian Mom. Thank you. Bless you.* We needed to find a Safeway, Starbucks or Seven-Eleven as soon as possible, however. "Where do villagers shop?" I asked casually, already planning the strategy.

"The PbIHOK-RYNOK," he replied. "The Market."

"The whaa? Oh, yes, of course the Plubkbl-rynock. We need to go there and pick up a few things," I said, unable to repeat the impossible word. In my opinion, the people who created the Russian language must have done it with nails and marbles in their mouths. I smiled up at Val. Actually I loved the language as long as I didn't have to speak it. I had learned a few basic words but PbIHOK had not been one of them.

"I believe we have everything we need for the week, Kiska."

"Except enough coffee," I smiled again, gripping my nearly empty cup.

"The PbIHOK is not close by, but perhaps we can find some coffee in the store in the next village. We shall be visiting villages and sights off and on for the next week."

I felt hope. Perhaps in a few days we could also find a little hotel with a hot shower and flush toilet. It would be my treat, of course. The slop bucket just wasn't going to cut it for an extended length of time. Bed Bath and Beyond needed to get over here, but I suspected they weren't ready for the Russian village yet.

Val was attentive, romantic and wonderful, extending every kindness, sharing tender feelings. These were only the beginning days of our weeks together, but he showed so much patience; his demanding behavior almost nonexistent. Was he truly changing, or was all of this simply because he was now in his native environment, his homeland? Whatever was going on, I knew I had a lot to learn and vowed I would begin by working on my slop bucket attitude.

That morning we picked the last of the apples in the orchard to store for the winter, then took a two-mile walk to another village, taking a lunch of fruits, bread and sausages from the basket of food Mom prepared for us. Val stopped now and then to chat and introduce his friends or acquaintances to his American wife. Did he throw in the *ex?* Of course I didn't know because I didn't understand much of what they were saying, but the smiles and nods between us filled the gaps and made nice connections. Since many (most?) of them had never seen an American up close, I was something of a novelty. Some of the villagers gathered by the well to visit, while others paused with their wooden carts or bicycles alongside the road as they carried groceries, water or grain to and from their houses. They were courteous, but curious, plying Val with question after question about me and life in America.

"Dasvid'aniya!" (Goodbye) I'd say with a wave as we walked on. I had learned a few basic Russian words, thank heavens. I realized I was an oddity, but I didn't want to be a totally stupid one.

I enjoyed walking with Val along the country road where the livestock grazed in the open fields under the

watchful care of the village herdsman and dogs. For years I had walked between two and three miles each day with my dog, so all this trekking suited me well. Crossing a wooden bridge into the next village, he pointed to the store, a faded yellow building resembling a portable modular structure. Although the coffee was outlandishly expensive, I bought enough for the remaining week. We strolled through the village, then returned to Volochyok when the rain clouds threatened.

The remainder of the afternoon we rested and simply enjoyed being together, connecting in ways we hadn't ever done before. It was cold, so Val built a fire in his apartment in the cow barn and we wrapped ourselves in blankets and snuggled by the fire. Being with him during those days (cow barn included) was as sweet as fresh hay and meadow honey. In his own native country, I felt the softer side of this Russian man; a side I had never known before except from his letters.

He was at home. Russia was home.

That evening we visited 90-year-old Anastasia and her daughter, Olga, who lived down the road. Val carried an empty gallon jug to exchange for the fresh milk from their cow. Anastasia, whom he called "Nastya," and her daughter supplied much of the milk and produce for the villagers, including Val and his mother during the summer months.

I felt as though I had stepped back in time when I entered this humble, ancient log dwelling—the house of the true Russian peasant from centuries past. Hansel and Gretel in Russia! Wearing a tattered sheepskin vest and handmade clothing, the beautiful elder woman (definitely not the wicked witch) with bright blue eyes greeted us warmly. Her daughter, Olga, rosy-cheeked and smiling, escorted us through the outer room where containers of dried fruits, grains and vegetables encircled us in a colorful garden of baskets and jars on the earthen floor. We removed our shoes and walked into the primitive kitchen-living area where a single light bulb hung from the ceiling, illuminating the tidy but sparsely furnished room.

Val had already spoken with Anastasia, so she was prepared to meet an American woman for the first time in her life. She reached out and took my hand, welcoming me

118

into the humble home where she had lived with her husband and two children most of her 90 years. Her husband had been in his mid-70's when he walked away into the woods and never came back, an event which sometimes happened in the Russian village when a family member is ill or dying, or simply chooses to leave the family. Not long after that, her son, Piter, was killed by a train in St. Petersburg. After the tragedies, Anastasia's daughter Olga left a successful manager position in St. Petersburg and returned to the village to stay with her mother. The pension was hardly enough, so they made their living by selling milk and produce in the village.

With her permission, I snapped a few photographs, including one of her heating the water for our tea on the single hot plate that served as their cooking stove except during winter months when they cooked and baked in the Russian stone oven and fireplace built into the wall. I will never forget them, and cherish the picture I took of Olga, Anastasia and Valentin, standing in front of that stone oven. As we were leaving, Olga hurried back out into the pouring rain to the cow barn and storage area, returning soaking wet with a gift of six of their best shining red apples in her outstretched apron! I wanted to cry.

We returned to Val's cottage and shortly after I had gone to sleep, someone knocked on the window at the foot of Val's bed. I froze. "It's okay, Kiska," he called to me. "Just a neighbor wanting a little vodka." They chatted through the open window for a few minutes, then Val got up and took some rubles out of his jeans and gave them to the man.

I'd heard about Russian hospitality, in fact I had been experiencing it, but this left me speechless. "Does this happen often?" I asked as soon as Val got back into bed.

"In the village, yes. Especially with this such kind-hearted person who has great problems with alcohol. He promises to bring some berries tomorrow, but I suppose he might forget."

I got to sleep finally, but shortly before the rooster and cows and dogs got started again, someone else knocked on our window. I almost fell out of the bed.

"Be calm, Kiska. Another friend," he reassured me, pulling the curtain aside and waving back. "Just saying good morning. They saw us arrive yesterday."

The pre-dawn sunrise filtered through the lace curtains as I lay back in the bed thinking about all of this. Good grief, no wonder Val wanted all the blinds up in our motor home during our honeymoon trip! While I insisted on lowering the shades at night for privacy, he not only wanted to enjoy the moon and stars but probably hoped some of the people walking past our windows in the campground would knock and chat awhile! I think the Russian village was already helping me to better understand this man I had married. And divorced.

The next few days were awe-inspiring as we drove, hiked and walked through old Russia. Ancient fortresses and monasteries and churches meandered between villages and rivers like brave stone-spirit vestiges of centuries past. Some of these sites dating back to the 1100's had just recently been returned to the church by the government. Taking this off-road journey with such a romantic and fun-loving guide was, indeed, a heady adventure. There were no Europa Hotels (oh, well) and tour buses in these magnificent walled cities and old villages where we enjoyed the sights and walked and talked, making strong and important connections.

We visited Pskov, where Val lived as a boy, walking through the Kremlin in the center courtyard of the ancient and beautiful walled city. He showed me the flat where he had lived with his parents and that evening treated me to a sumptuous dinner of Russian-style pork with cheese, mushrooms and potatoes in a nearby restaurant. Our food supply was running short which meant (thank you, God) we were going to get to eat in restaurants—if we could find them—more often. Dining out in Russia was expensive and not traditional and although it was becoming more popular in the urban areas, Val preferred home-prepared meals. This time there wasn't much choice.

From there we traveled on to Pechory, a picturesque town with an incredible ancient priory and church. We chatted with a monk in apprenticeship, a man my own age who had decided to give his life to God in this way at this

time in his life. I couldn't imagine such a life and admired his energy, warmth and conviction. Val then proceeded to give me the good (thrilling) news that he had reserved a hotel for the next few days in order to continue on and visit these ancient sites further on into the Russian countryside. Up until now, we had been returning to the village house each evening. Now we drove on to *Pushkin's Mounts,* the town of the famous poet-writer, Pushkin, arriving at the hotel just after dark. Charming and cozy, we had a warm shower, toilet that flushed and a hot breakfast served early the next morning. I ate my liver and paste (I hate liver) and eggs and drank the tea. One learns to count one's blessings. For starters, I had a bearded one sitting across the table from me. I leaned over and kissed him.

The real Russian village life was unforgettable. For the next few days, I saw the true peasant life all around me—meeting and chatting (via my interpreter) with these wonderful people by the side of the road—people hauling hay and water in primitive hand-hewn wooden carts. Three men who were plowing a field of potatoes with their ancient iron plows pulled by horses came over to greet us, clearly overwhelmed at meeting a flesh-and-blood American woman. They gifted us with a huge sack of potatoes, which we carried for miles!

Pushkin's estate and the 1569 church where he and his family were buried was an awe-inspiring sight and the three-mile walk home through the woods (with the potatoes) under a crisp sunny sky was a day I shall always remember. We left the hotel the next morning after a hearty breakfast of hot porridge, breads, cheese and tea, then drove back to the dacha and closed it down for winter, packing up our belongings and the boxes of apples, returning to St. Petersburg through the states of Pskov, Novgorod and Petersburg.

When we arrived that evening, a phone message from Victor gave us the news that my father had passed away on Sunday evening, October 16th. A virus swept through the nursing home and took him quickly, peacefully. Surrounded by my brother and the nurses and aides and friends who loved him, he left this world with Anne Murray singing *Amazing Grace,* his favorite CD.

I cried and cried in Valentin's gentle arms, knowing it was merciful that my father didn't linger with his cancer, yet grieving my loss and feeling sadness that I couldn't have been there with him. I wonder if Dad waited until I was in Russia. It would be just like him to keep me from making a fuss.

*Dad . . .*

The next day Val and his mother took me to the cemetery in St. Petersburg where his father and the family were buried. It was, I think, the best way for me to begin my grieving process, and they knew it. The crisp November winds stirred the dry leaves as we swept the iron-fenced family plot and polished the embedded portraits on the stones. *You have moved on, Dad . . . as they. We'll remember you forever. I'll miss you.*

The next days were quiet ones. Val and I walked in the birch woods nearby almost every day—sometimes four to six miles if we included the trips to and from trains, subways, buses or to his car's garage, which is one mile from his flat. We stored the apples in the ground below the floor of his garage for the winter, and enjoyed Mom's sumptuous Russian cooking as the fall days became colder. I met and spent time with his two charming daughters and seven-year-old grandson, Vadim. Dasha was fifteen and lived in St. Petersburg, and Katia, a children's doctor, lived with her son (Val's grandson), in Moscow. Val and his family were wonderful. I began to understand more about this man I had married as I watched him and his mother interact on a day-to-day basis.

I remember the first time I hugged and thanked her for the beautiful dinner she had prepared for us. She seemed surprised, though not displeased at my gesture. "Why did you do that?" Val asked me later.

"Why not?" I replied. "She has worked all day in the kitchen."

"It is her duty."

That was huge. *No wonder he expected so much from me . . .*

During the days that followed, I enjoyed our visits with his friends in St. Petersburg and in the surrounding villages, including my first, authentic Russian sauna

complete with stunning cold bucket shower. I loved St. Petersburg, with all its historic beauty, museums and ancient history. His delightful friends treated us to delicious meals, including shchi (Russian soup with cabbage), and introduced me to some of the culture of this great city, including *Carmen,* at the historic St. Petersburg Opera House. Over and over again I found myself the honored guest in homes of friends and family, enjoying food and hospitality beyond anything I had ever experienced before. The Russian people pour out their hearts and hearths to guests and friends, and Val's American wife was no exception.

For some, the lavish meals were a sacrifice. I remember Val's friend Sergey, and his young wife, Irina, who were clearly struggling on his meager income as a photographer. Their gracious hospitality in their simple one-room studio apartment overwhelmed me. The stark, stone apartment building looked like something out of Dr. Zhivago. I held on to the iron-grated elevator rattling up to the flat they shared with two other families; walking into their small room made bright and colorful with maps and Sergey's photographs papering the dismal walls. I knew they had sacrificed to make the dinner and evening elegant. And it was. Irina, wearing a flowing dress and beautiful smile, had I'm sure, spent hours on the dinner of fish, potatoes and mushrooms. Sergey Grigorev donning his western cowboy hat (for Calamity's benefit?) showed me some of the most stunning photography I had ever seen in my life. I knew immediately that his work was brilliant, yet wondered if he would ever be known and recognized outside this humble flat in Russia. My father would have considered it a privilege to meet such an incredible photographer. I was honored to be a guest in their home and hoped one day Sergey would be recognized. When I left he gave me one of his photographs.

All of this continued to teach me so much about Valentin and his culture, his world.

There was so much more, of course. During our weeks together, we had a few disagreements and grappled with them and with the issues that had faced us in the past and might face us again. It was still so difficult for

Val to discuss these things and share his feelings when these problems arose. During our struggles, I watched him back away emotionally and move into an evasive or defensive stance. I realized this might be a pattern and that if we decided to try one more time, I might have to accept and live with it. Could I? Should I?

There were so many questions still unanswered, but for me, the issue of trust was the biggest. If I couldn't trust him, I couldn't marry him again. During our weeks together in Russia, the dishonesty surfaced once again. Before I agreed to this trip, Valentin assured me he had gotten counseling with a university friend who had her degree, but during an evening with this woman, it was apparent he had not. Would he be able to overcome his cultural predilection and be strong and wise enough to make deliberate choices not to lie or deceive me again? Could he get through the cultural, psychological and familial barriers that separated him from himself and from me? It was huge, and I wasn't sure we could do it.

I loved him so much and I wanted to trust him again, but could we make it one more time? I knew I had to work out my own trust issues as well, and maybe the coming year would give both of us the opportunity to grow and make the changes we needed to make. I wanted it. This trip had taught me so much about Valentin and some of the reasons he is the way he is. And it taught me a lot about myself. Life with him might not be easy, but I knew (oh, yeah) it would be an adventure.

*Monday, October 30th, 2000*

The snow dusted the ground as he carried my luggage out to his car. My Russian mom and I held each other and said goodbye through our tears. Driving away, I glanced up at her on the seventh floor balcony, waving. I waved back, reminding Val to give her extra love from me. He promised he would.

At the airport Val and I simply held each other and cried, placing our wedding rings back on our fingers before we said goodbye. I remember that during our first marriage he seldom wore his ring. Would that change if we married again?

I turned and walked away, moving through customs and ticketing, watching him behind the glass reaching toward me, his ring finger pressed against the glass. I stepped out of the line and moved toward him. We pressed our rings against the glass, against each other. A promise. A vow to keep. *Dear God, please help me. Help us. One more time.*

Northwest Flight 0037W lifted off the at the Pulkovo St. Petersburg International Airport runway at 2:20 in the afternoon. I waved through the fogged window, but I couldn't see much of anything because there was snow, and there were tears.

# CHAPTER SEVEN
## Uncozy

*I feel your love through the ocean and miss you so
much. I am so glad that you feel my love and begin to trust
me, my feelings. Thank you my Jany, and God. I feel so
uncozy without you.*
—Valentin

I flew home and prepared for my father's memorial service. Thoughts of Valentin wove through the busy days of planning Dad's service and dealing with all of the final issues of closing up and selling his little house on five acres. *I am uncozy, too, Valentin. I wish you were here to help me and take care of the orchard. His apples need to be harvested. And I need your shoulder.*

My brother and two sisters flew in to support me physically and emotionally during this difficult time, and I'm so grateful for them and for the diversion. Dad's service was held on November 15th, 2000 in a Community Center along the banks of the Little White Salmon River. Cal Crook would not be forgotten. Even though he had moved on, in so many ways Dad was still there with us. I remember how he loved standing on the bridge at BZ Corners or hiking along the steep banks of the Little White Salmon, photographing the whitewater rafters and canoeists coming down the rapids. I remember all the fences he crawled under and mountains he climbed and still smile at the memories. His historic photographic images of this magnificent countryside meandering between Mt. Adams, the mighty Columbia River and Mt. Hood will live on for generations. *Thank you, Dad.*

*15 November, 2000*

*Hi my Sweetheart. I am quite well, though I have to work a lot. I want to make the most of the necessary money as soon as possible, because I have need of you. I want to be close to you and I am sure we will be happy. Please say goodbye to Dad. I will be with you and your family during his memorial. Mom is okay. Today is her 75th birthday. She sends you her best wishes. She really loves you. I miss you so much. My love becomes stronger, my dear Jany. Please take my tender kisses and hugs. I try to change bad boy to good.*

Oh, Valentin! I love you.

*21 November, 2000*

*I'm glad that you are in your cozy house again. I send my love and care. Thank you for your care and prayers. I feel your love every minute. Mom is all right. Our relationship became calmer and more tender. It is your influence, Jany. Thank you! I miss you so much. Say hello to your family.*

I remember Valentin's surprise when I suggested he thank his mother for the meals she prepared, instead of showing impatience that the food or preparation was not exactly as he wished. "Instead of your disapproval, she needs you to thank her and give her a hug, even a kiss on the cheek now and then," I told him. "She needs this affection so much, Val." This surprised him, because there had been very little physical contact and outward affection between them other than outbursts of her anger (pain?) at unexpected intervals which surprised and disturbed him.

*22 November, 2000*

*Hello my Kiska. I got your parcel yesterday. Thank you! I eager that we be together because life is so short. I want to be with you as soon as possible. I feel your love very close. Thank you, Honey.*

I had sent a parcel for the family including some food and gifts for Anastasia and Olga in the village. My Russian mom loved the coffee the most! (I understood.)

*4 December, 2000*

*My Jany! The hardest thing is to be so far from you. We have had nice days over there, and though some of them were very hard for us, now I feel you really love me and know I love you stronger. It strengthens me, too. And we need God to be our foundation. I understand that it is not so easy for you to forget our worst days. I will wait, we need time for healing. The communication is the most important thing and we will work together to save our love, to restore our relationship. I want this. The life is so short and we deserve happy years. I want to be with you as soon as possible and I am sure we will be happy through the patience and truth. I love you my Calamity. I feel your love and great care about me. Thank you, Darling. I hug and kiss you. Goodnight.*

His letters touched me and brought tears during those long, cold days. This tender, affectionate man had so much love inside of him, so much to give. I wanted to believe he loved me and wanted only to be loved in return, yet when we had been together during our first marriage, our relationship took on a completely different dynamic. Closeness and emotional intimacy became almost impossible for him. *Why,* I wondered? Did it have anything to do with growing up under communism? Or was there more? There were many Russians who grew up in this same culture who were not this way. My friend Irina happened to be one of them. I wanted to learn and understand more about him and about myself, because I knew that we had to overcome certain obstacles if our second marriage was going to survive. Doing the risk didn't mean doing it blindly or stupidly.

*I have given you the tools.*
    *Okay . . .*

*13 December, 2000*

*Hello Jany. I am sad about your Mom and her fall. The old ages are so hard if somebody is alone. Mom sends to you and Ethel her best wishes and good health. She wants us to be together. I am with you every moment my Darling. I am so lonely without you. You are so close to my heart, but I need our communication and your spiritual help. Please take care of yourself and stay peaceful. You became and are a part of me—the best part. I am okay and work hard to make money as soon as possible. Say hello to your family. I love you Kiska. I am sure God helps us.*

My mother had a fall. She was 90 now and although these things weren't unexpected, they were hard for all of us. Thankfully, my brother and his wife lived close to her, which made it easier for me, since I was still taking care of the final details of my father's passing. It was heartening to know that Val's mother wanted us to be together. He and his mother struggled to coexist peacefully and while it had been practical and financially beneficial for them to do this, I realized that living together might not be the best solution for them. Knowing that helped a little as I thought about her future alone in the flat once again, if we should marry again. She had all of the things she needed, but she wouldn't have her son with her from day-to-day anymore. And after Val's father passed on, she had totally devoted her life to him. Totally.

*21 December, 2000*

*Hello my Dearest Jany-Kiska, my friend and love. Merry Christmas and a Happy New Year to you and your family! I wish you great health and peace. We will be together forever soon. I kiss you many times.*
*Merry Christmas, Sweetheart.*

I missed him so much and hoped he was enjoying his holiday with his mom and family. The kisses made my days and nights sweeter.

*3 January, 2001*

*Hi my Dearest! I am alive and not in bad shape after some break days. The New Year was very calm. Mom and I drank a little bit of red wine, ate some delicious food, watched TV, then went to bed. Your call was so wonderful. Thank you for care and love. I feel them every day. After dentist costs I can make enough money for ticket, visa and a little bit more. Don't send me any money. I can do this myself. I want to apply for a visa as soon as possible. We need to be together. I love you my Kiska and want to be with you till the day God calls us to Him. Be healthy and peaceful. With tender hugs, Valentin*

*Valentin Gudkov. I want to be with you, too, until that day . . .*

Sometimes his letters filled me so full that I'd find myself curled up on the sheepskin rug by the fire smiling this idiotic smile. Or laughing because I'm 64 and probably kicking up a little too much dust for somebody my age. But then, why not? I suspect there might be a few other women like myself who would seriously consider doing the same crazy, stupid thing if they had the chance. *Wouldn't they?*

He is an amazing man, and I don't want to walk through my final years without him. I just hope we don't fall off the cliff.

*18 January, 2001*

*My Jany, Hello! I am at home for three days already. After the hard work during last holidays, I had a stomach ache and decided to take a rest. The doctors made all tests and said that it was not an ulcer, but only a gastritis spasm and, maybe something out of order with my pancreas or gallbladder. My physician supposed that the reason of this disorder and pain was the nervous conditions of my job. It is the life as it is. Now I am okay, out of pain and have a lot of time for sleeping reading and a response for your letter.*

*Thank you my dear Kiska, for such warm and honest message. I have been happy near you and have learnt and taken many good things and new feelings from our relation-*

*ship. You have given me so much. I want to do the same for you. God is so great to give us one more chance to keep our love. I am sure we will be good and patient pupils of Him and do our best. I want so much to renew our marriage and have you as my only friend, partner, lover—WIFE. I want you to trust me that you are the only woman whom I love and want. And I trust you, my sweet Jany.*

*It is so pleasant but not easy job to write letters, my Calamity. I did not like to do it all my life. I am not so good writer, but I am trying and studying. Now, it is time to go to bed. I keep you, my Kiska, in my arms.*

His arms wrapped me up and kept me so warm during these cold January days. I was thankful he felt better and that his mom took such good care of him. She would be a hard act to follow, but now I think he understood it was an act I wouldn't always follow. I'm not a Russian woman. I'm from another culture, and that was that. One thing I did have in common with Val's Russian mom was that we both loved him very much. I truly believed the Little Emperor had stepped down and was ready for the new life partnership with his American wife. I hoped I was finally getting it and hadn't been watching too many Dr. Zhivago reruns.

It had been almost three years since that first letter arrived in my mailbox: *Let me introduce myself. I am Valentin Goudkov. October 7th, 1946 is my birthday . . .* Wow. Calamity Jan and the Russian. The FBI and the KGB. Little did I know then what lay ahead, yet in spite of all that had happened, I still wanted to try to put the pieces back together again. Maybe everything we had learned in the first marriage would make a difference the second time around. I wanted so much to believe that; I wanted so much to love him like he had never been loved—to let the dance merge with the music of our hearts and carry us toward our final years together.

Dr Lee Jampolsky said: "Love is not to be figured out or understood with the mind: It is to be experienced with the heart."

*21 January, 2001*

*Hello my Darling again. Today I have had a nice walk in our woods. I walked about two hours among the trees, prayed near my favorite birch and remembered our walks together. Everything was so good, except one thing; I felt so lonely without you. I love you and feel your love and care. Next week my dentist begins the work on my teeth. Thank you for your so wise and helpful letter. I agree with all your thoughts. I trust you, my Kiska, and eager to be a good and close friend, partner, lover and husband to you. I kiss you.*

I remembered the birch woods near his flat, where we often walked during our days together in St. Petersburg. I missed holding his hand, missed our connection. Why was something as simple as touch and those connections so powerful? I wanted to understand more. Those days and walks were beautiful. Something happened during those quiet days in the quiet woods when words didn't matter. Love. God. I believed we were destined to find each other in new ways that had finally begun to connect our souls.

*5 February, 2001*

*My Jany Hello. Best wishes to Ethel. I am very glad she is better. Mom is okay too. We will be wiser and more patient in our new life. We both want this. The dentist-physician took off the nerves from some of my teeth and did preparation work. I have already lost five pounds, but I am okay spiritually because you are with me every moment. I am preparing the visa documents now. I hope everything will be all right. This weekend I will go to the country to my friend Fedor to have sauna, a little rest and walk in the woods. I miss and kiss you. Best wishes to your great children.*

I wanted so much to be with him during this time, but I couldn't. I wrote and e-mailed often. I knew he needed this work done on his teeth due to his problems with gingivitis after his ulcer and digestive issues, and I was certain he would be glad when it was over. Of course he needed that sauna and time of resting in Fedor's country

house. I had already begun to look around for a sauna near where I lived, so that Val might find—in some small way, that Russian connection he needed so much. Still, neither he (nor I) could bring Russia to America, not even with a sauna. Certain empty places could never be filled by me or the new life here, and I knew it. There were connections with his homeland that he would lose, and I wondered if he was prepared now and would make it this time.

*1 March, 2001*

*Hello Kiska. I am very glad that everybody is okay after the earthquake. I was worried about you and did not sleep well for two nights. I am so upset also about our visa delay but know we will be together. I feel your love and care. Thank you, Honey. I have gained four pounds already since dentist work is finished. I will ski this weekend. Say hello to Michal and best wishes to her on her birthday.*

We had a serious 6.8 earthquake with the epicenter in Olympia, close to where I live. Bridges were down and buildings crumbled, but no one was seriously injured. "The bridge went down, but at least my house didn't collapse on top of me," I wrote him. "Cider and I are still alive and I'm so glad you are, too. Just keep getting better and gaining weight, okay?" I tried to keep his spirit (and mine) upbeat and positive. "Your health is the next most important thing. And then the visa."

*2 March, 2001*

*Hello Jany. I am very glad that everybody is okay after the earthquake. God cares for your great family. Best regards to them. I have been so upset for some days but now feel more peaceful. I feel that Father forgives me for what I have done to you and your family. Thank you for your love and care. I cannot imagine the future life without you, my Kiska. Try to trust me. I love you so much.*

When things go wrong I think Valentin believes God may be punishing him. I wrote and gave him some of my

thoughts—hoping to explain how I believed that most of us are responsible when we make mistakes and that there are consequences when we do. It's not a matter of being punished, even though those consequences resulting from our unwise choices may feel like punishment. I have learned that the heart of God is not as much about punishment as it is about supplying what is missing in our character that caused us to make the poor choice in the first place. Sometimes though, negative life circumstances are totally out of our control. I think I am beginning to understand that no matter what happens in our lives, the God of the Universe is holding us and helping us, especially when we cannot help ourselves. I know this because I've experienced it again and again. I'm experiencing it.

*I have given you the tools* is an eternal Truth. I'm learning the *tools* are natural and amazing gifts which belong to me—to all of us—and which, when touched by God, can be multiplied and go forth like the loaves and the fishes. God does help those who help themselves, but life has also taught me that God helps those who cannot help themselves, and it is during those impossible days when there seems to be no hope, that I have learned about Miracles.

Val and I talk through our letters because the spiritual is so basic—so foundational for both of us. I realized that almost immediately when he sent me my first gift—the small wooden egg. *It is Russian Easter egg,* he wrote. *The initials "XB" (Russian letters) equal to "CR" mean "Christ Resuscitates." It is from the Bible. It is the Russian beautiful tradition to present such eggs during Easter with kiss. I am not very religious person, but I believe in God the creator of nature, people, love, everything outside and inside us. I love Him and feel that He love and help me.*

I feel such a strong connection with this man. Sometimes I wish I didn't. Life would have been simpler, more predictable without him. But he entered my life and that changed everything. Everything.

I am not the woman I was the day he met me at the airport. I am not the woman I was when we said goodbye

at that same airport. I'm not the woman I was in Russia when I began to live in his world and understand more. I'm not the same woman today as I was yesterday.

I'm stronger now because I know these difficult challenges and circumstances are all part of the process of reclaiming myself. Believing in myself. *Trusting myself.*

*. . . And in the pieces, I found who I was.*

*8 March, 2001*

*Hello Jany, my Dearest Calamity. I'm alone in Fedor's country house in the small room near the stove. It is the full moon and many, many stars in the sky. The house is 50 miles in the north and a nice place among the woods, very similar to BZ Corners, but without fast river and Mt. Adams. Today is the Woman's day in our country. It is three-days holiday together with the weekend. My friend Fedor has had to stay in the city with his family but will come tomorrow morning. I skied in the woods and on two lakes for two hours. Here is a lot of snow, about 20 inches. I walked after the dinner for an hour in the neighborhood. Now I'm trying to respond to your very honest letter. Thank you, Sweetie for trusting me and for wish to share your life with me. Thank you for sharing dreams and spiritual life with me. I want to build life on Rock, not on sand and to have you close to me. We are both imperfect persons and so different, and to my mind, it is not so bad. If we were perfect and similar, it would be so uninteresting and boring. I know that we are moving closer and closer to each other from day-to-day, from the letter to the letter. I love you, Honey and I am convinced that you are a very normal and attractive woman, great friend and lover for me. I hope God will give us many active years and we will be together till the end of our lives in this world and in another world, too. God bless you my Kiska.*

God bless you my Valentin, and you are my Valentine. Sometimes I feel completely overwhelmed with your letters (your love), and I don't even know how to respond. One thing I do know, though, is that you are so right—life together will never be uninteresting and boring.

*12 March, 2001*

*Hello Kiska. The ski, sauna, weather, walks and Fedor's company were wonderful. It was a great relaxation. If you were here, you would enjoy it too. Poor Cider. She is so old. I miss her and her owner and our walks. Kiska, with all the problems, the only way for us to get back together may be the fiancé visa. I can make some extra money in the next six or seven months. It is not enough for an attorney, but it is all I can do. I will tell you when they inform me.*

*Jany, be very good and healthy; eat more fruits, vegetables and hot porridges. I am with you.*

Porridges? Okaay—here we go again! Yes, I will eat more hot porridges. And the sauna? Oh, Lord! That stifling heat and those cold bucket showers! I don't know about the Russian sauna, my Darling! As for the fiancé visa—*maybe we can pull that one off.*

*13 March, 2001*

*Hello my Dearest. Yesterday I was in the church and prayed for all of us. I miss you every moment. My love becomes deeper. Do you feel it? The sunset was so beautiful on Sunday. It reminded me of our last sunset on the beach. I kiss you, Kiska.*

I remember that night and the sunset. Our divorce was final and Val was leaving the next day. We sat on a log and held hands and cried a little. I guess love doesn't just disappear like the sunset. In a way it does, though; but like the sunset, it keeps coming back. And the next sunset is always different, sometimes more beautiful.

Like love.

*14 March, 2001*

*Hi my Dearest. Now I am in the office, but I can't work and need to talk to you. Our visa will not be granted. It is such terrible nonsense and injustice in our society that two persons who love each other can't be together! It is very*

*hard to live so far from you my Love, and more times harder to feel helplessness before the circumstances of reality which I cannot change. I am very upset but I will try to be calm, strong and healthy. I hope, my Sweetheart, that one day we will be together not only spiritually, but physically too. Help us, Father! You are right Honey, that it was hard for me to live in an unknown country, but it is many times harder to live in my native one without you.*

*Oh, the hard day is over. I visited the Vladimirskaya Church* (we had visited it)*, prayed and lit three candles: the first for the memory of our relatives and all Christians who had passed away, the second for us and our future, and the last one for our relatives and our health. Now it is a great fasting (40 days) before Easter. All the priests were in black clothes. The churches here are opened all the day long (as usual), but the evening services are served only on Saturdays and Sundays. I feel better after the church.*

*There was a lot of snow but now it is melting. Here is very wet and dirty on the streets, but I have the boots you sent me for such nasty weather. They are comfortable and dry inside. Thank you, Kiska, for care. Oh, I'm so tired. It is time to go to bed. Your warm self is near me. My arms are around you. Goodnight my Calamity.*

The situation with the visa was disheartening, but I believed we were going to make it. It wasn't going to be easy for him to return, yet now he wanted this life with me as never before. We'd had a great fall and still faced huge obstacles, yet somehow I believed we had a chance to get the fragmented pieces of our lives back together again.

*20 March, 2001*

*Hello Jany. Today I visited the department of marriages in our Central City Hall. It was closed. It works only two days a week. I met in it, two couples: the women were Russian, one man from France, the other from the United States. They had the same problem as we. The men prepared the documents and came to St. Petersburg to get married here because it is the only way to get visa for their brides. We have a chance too, my Sweetheart. Maybe the*

*fiancé visa if this does not work. I love you so strong and it
is so hard to live without you.*

Return to St. Petersburg to get married? I felt a catch
in my throat.

*22 March, 2001*

*Hi my Dearest. My congratulations to you with Blake's
birthday. You have very special children. I miss them and
YOU. I love you, Kiska. My shoulders and arms are near
and around you. I try to help you through the ocean. Do you
feel it? I feel your love and care every moment. It helps me
to survive. If I were closer, I could do all hard work in the
house, around it and in Dad's country house. Together we
will work and go through all troubles. I miss you, my Jany.
I will go to Fedor this weekend. Maybe it is the last time for
skiing. The weather becomes warmer here now. I love you.*

My friends and family now realize I am making
inquiries about the fiancé visa and that Val and I are going
to try to get back together again. Some remain concerned
that his focus is to get back over here and get that green
card, while others continue to believe that he plans to take
advantage of me financially. I explain that both of those
concerns are without substance. If he had wanted to get
his green card he would have stayed in the United States
after our divorce, and if he had wanted my money (what
little I had) he would have contested the divorce. I have
rationalized his words to Svetlana (and possibly others),
believing—hoping they were a desperate attempt to bolster
his own faltering self-esteem when things were not going
well for us. I have learned a lot about this man, especially
after spending some time with him in his own culture,
surrounded by his friends and family. During those days
and weeks in Russia, I believed he truly loved me; and
that in spite of the cultural challenges we were both going
to face (again) if we got back together, our love was strong
and our love, hard work and faith could see us through. I
now see how alone and alienated he must have felt in a
totally foreign culture and how difficult it must have been
for him during our marriage. Most of my friends and

family understand that we still love each other and while some feel uneasy about me taking on this challenge once again, they support me and honor my right to make this decision myself.

*3 April, 2001*

*Hello Jany. I am at Victor's office. I have got your e-mail but could not reply because of the disorder in my computer line. I sent you three messages with some information and my love. I will work hard to make enough money for visa. I cannot imagine the life without you.*

I'm dreaming of a life with him again. I cannot imagine life without him now . . .

*16 April, 2001*

*Kiska, hello from the still cold and snowy country. In spite of the worst weather, I am alive and all right. I visited the church on Friday, Sunday and today. On Sunday evening Mom and I visited the church and then we watched the play by Bernard Shaw in one of our theatres. I prayed for us and your visit to the attorney about visa. I hope it will be successful. Good luck, my Dearest*

The immigration attorney believes we can get this visa and will assist us in doing so. I explain which documents Val must send in order to begin the process. Over the course of the next month, we continued to write and talk through our letters, phone calls and e-mails. Our connections grew stronger and deeper. Sometimes I felt his arms and spirit holding me during the cluttered days and nights of preparation and longing.

*May 3, 2001*

*Hello my Dearest. I will send documents by express mail. Our future will be the real result of hard work, learning from failure and faith to God. I am with you Sweetheart and love you stronger and stronger.*

*The holiday with Katia, Vadim and Mom in the village was good. We had done the vegetable beds and planted seeds. The weather was nice for this season. Katia gave the photos you took to the village women. They were very thankful to you. I miss my wild and calm Calamity!*

*Thank you for your letters. Our connection became closer. I appreciate it so much. I feel that something is changing inside me from day-to-day. I know God helps me, helps us. You—my Kiska, help me a lot, too. I feel your care and love every moment. Although we lost much time to live so far from each other, I am sure that time was useful for us, especially for me. I understood and know, exactly now, that you are the only one whom I love and need. And God is our rock and foundation. Jany, you showed and show me this way. I am so thankful to my tender Calamity Girl. We are so different, but we are the One. We will have much time ahead to work patiently and passionately with each other and reach the wholeness of our souls and bodies and spirits. We are healthy; it is so much. We are not wealthy, it is so unimportant—nothing. I need you. Let's be peaceful. Good night, Sweetie.*

So much is changing inside me, too. I truly believe we are going to be able to make this marriage work. I wish we had more time, though. The fiancé visa requires that we must marry in three months which, in my opinion, is not enough time for two people to really get to know each other (again). But, a visa isn't easy to get, and we have no other choice unless we wish to wait—for how long? Years, perhaps? I keep busy with my writing, school presentations and new business venture in publishing which make the days and nights shorter until we are together again.

*14 May, 2001*

*Hi my Dearest. Fedor and I visited our friend Kirill in his country house. It is about 80 miles to the north from St. Petersburg. The place is wonderful, in the woods on the bank of the big lake. We fished, picked up the early mushrooms, got the sauna although the weather was cold and windy. I relaxed very well. I felt the closeness of God through the great Nature which He has established. He*

*gave us so great world, the unity of human beings and love. He reveals Himself in everything. He gives us to each other and we will be together in spite of the difficulties and differences, my lovely Friend, Lover, Cook, the youngest Calamity Girl. If we have some problems, we will go to counseling. I agree, Honey—it is wiser to have a counselor than to be silent and hold spirit splinters inside oneself. We will work, maybe hard, but honestly and with laugh, not anger. I like your kitchen, and especially bedroom. We will solve all the problems in both of them.*

*God is giving us back to each other. I thank Him. I love you.*

Oh Valentin, may we drive the spirit splinters away with such amazing wisdom! A counselor? Your willingness to open those new doors (if we should need this) *gives me so much hope.* "I know you love the kitchen and the bedroom, my darling," I wrote him, "but if we can't find our way with laugh, not anger—then we shall get someone else to help us. We can do it this time. I know we can! I love you so much."

The yellow caution light wasn't blinking anymore.

*29 May, 2001*

*Hello my Dearest Kiska. I was very busy because I had to work overtime last week. Every day I came back to my flat at midnight. I have done some money for my visa. I am tired, but I am alive and okay, in spite of the very cold weather. Only your warm care and love save me here. I keep you in my heart and mind.*

I continued working with the attorney on getting the necessary paperwork and documents for the visa. I finally called Val because I just missed hearing his voice.

*26 July, 2001*

*Hello my Dearest. It was so nice to hear your voice. Sorry for my e-mail silence and job problems. But I am alive, cool and in good shape. I love you and pray for us, for your health and peace. During last year I read your Bible,*

*visited church many more times than ever and thought much about Christianity. It was not easy, but I felt and understand many more things, and feel now your help, care and support. I'm calm and peaceful and feel closer and closer to Him. Your love, Kiska, helps me on my way. You are so right. Honesty—Truth is the foundation. I was dishonest to you but it was the last time in our life. I will trust me and I will be patient. We can do it and be happy, honorable to each other. For many years I saw only black and white in my life, and only now, I begin to see, feel and understand that there are so many different colors. Thanks God and you, Calamity for this GIFT. I love you and feel your love. I pray for you.*

So many different colors . . . *only now, I begin to see, feel and understand that there are so many different colors.* Yes, he is right. So many of us find ourselves growing up within the black and white fences of ideologies, religion, culture . . . while our deeper selves know there is so much more, and we hunger for it. Our spirits thirst for the sunrises and sunsets, for horizons beyond where winds spin rainbows and stars throw kisses at midnight.

*Your love, Kiska, helps me on my way.*

Oh Valentin!

Yes, it is love. LOVE . . .

*29 July, 2001*

*It is Sunday morning in the village. I am in the garden, the sun is shining and I am taking the vitamin D. It is the first sunny morning after the week of the strong rains. A lot of black and red currant and cherry are harvested. Mom cooked jam and Vadim helped her in picking them. It is so wonderful to be outside, not in the city and not to work hard. (But this is the life as it is here. We have to work the best part of our lives!) Nature is the best healer for me and you, Honey. We are different, but in Nature there are so many different things too, and all of them live and grow together. They share and add each other and help each other and we are the small pieces of the Great Nature. We are different, but I'm sure we can live in peace and fun and understanding. I want this because I love you.*

*Now I have to stop and do some sticks for supporting the apple tree's branches. There are so many apples this summer that some branches are so heavy and have broken.*

*I am with you Kiska, again. I didn't cry for us, but I was and am so lonely, though I live in my native country among my family and friends. I am sure I have lost so much without you and your family. My Mom and Katia are sad for us. Maybe they feel (as women) that I have lost the best woman, friend and partner—you. I'm sure God will show us the way.*

*. . . some branches are so heavy and have broken.*

"Like us, Valentin. I'm not crying now, but I'm missing you, too. I'm wanting my best friend and partner. I'm wanting you."

*20 August, 2001*

*Hello my Dearest. I was in the village for two days. The weather was gloomy, rainy, but warm, about 60 F. I came back with Mom. She is very good and is going to go to Moscow to help Katia with Vadim during his first months at school. Now he is a first-grade student and he is very proud. He is such a wonderful boy. I miss him and your wonderful grandchildren too. But most of all I miss and love you—my Calamity Kiska. God gave us the second chance to be together and we have to take His gift and to build the safe place for each other through our happy marriage. I agree with you, my strong and tender girl, we can do it and grow our love from day-to-day. You are truly mine and I'm yours, because we both have the one foundation. It is the True Christianity. It is so good to feel it and look forward without fear. Thank you, Honey. You helped me to reach this peace. Your love and forgiveness showed me the way.*

*Maybe we will have some problems, but I am sure we can go through them with the help of God and our patience to each other. We will have our best years. I pray for this and your peace and health, my Jany. I'm with you. With kisses, Val*

How could this marriage not work? Our second chance. I am finding so much strength and wisdom as I

read the songs of David (the Psalms) in the Bible. I'm also reading "*Wedded Strangers*" again, and this time I'm paying more attention.

*September 11, 2001* (Twin Towers tragedy. Word has not reached Valentin yet)

*Hello Kiska! I love you! Happy birthday soon to the youngest and prettiest Girl of the Wild West. Great love and health to you, my darling. I am at Victor's now. He is helping us. Thank you for the document information and the e-mail. The life is so short and unpredictable. We have to value every moment. God bless every day. I am happy, Honey. Mom is okay too, and at home now. I send you my love.*

When I called Val to tell him about our 9/11 tragedy, he had already heard the news. Everyone was in a state of disbelief.

*12 September, 2001*

*Hello Jany. Thank you for the call. I am very sad for the greatest tragedy there. It is a terrible crime of madmen. There are so many madmen in the world. They don't want to live in peace and love.*
*I will go to the village, maybe several times more in September-October to close the house and to fish. There was not even one apple last year because of the frost during the blossoming in spring. We were without apples last winter and it was bad. My job is going well. The main worry is the situation in the United States consulate now. If it is okay, I will depart on 13th of December and we will be together on Christmas. It is not far, my Darling. God helps us. I close and go to the post office. With love, Val*

*September 14, 2001* (From Victor, Val's good friend)

*Dear Janette. This is just to let you know how deeply all of us here are regretting about all of horrible things which have happened. You know, people are bringing lot of flowers to American General Consulate here in St. Peters-*

*burg and many of them are crying. Let's hope that the Holy*
*Lord will help you all to overcome this tragedy.*
*Yours, Victor, Galina and all of us here.*

Two days after Victor's touching letter to me, he died
of a heart attack. It happened on my birthday and was a
terrible shock. Victor was a wonderful man and had
endeared himself to me during the brief time I had known
him. I still remember his warm smile, his hearty hug and
the beautiful flowers he handed me at the airport when I
arrived in St. Petersburg. This was an especially hard time
for Val, so most of my connections with him during those
long, difficult weeks were by phone. Often he would simply
say to me, "The Life is so short, Jany," and it was true. Val
had to journey through his grief alone and while he did, I
focused on my writing and made preparations for his
return.

*2 November, 2001*

*Hello my Dear Calamity Kiska. It was so special*
*sharing with you our happiness of getting the visa. I felt it*
*finally only when you called me. I was so nervous during*
*the waiting days in Moscow, that I could not understand*
*the reality of this. God helped me—helped us once more. I*
*thank Him so much. In spite of those hard days, I spent*
*very pleasant time with Vadim and Katia. I went to Vadim's*
*school, walked with him every day.*

*Thank you, Honey, for your letter and great cards. I*
*appreciate your way of preparing me to be a good cook*
*sometimes. But sometimes I need your great pies, pastries,*
*jam, Mexican food, baked fish and potato and . . . YOU! You*
*are the most delicious for Russian boy.*

*Tomorrow morning Mom and I will go to the village to*
*conserve the house for winter. Goodnight Jany.*

*Goodnight, Russian boy. I love you so much. Keep*
*focusing and preparing yourself to share your wonderful*
*cooking with your slightly independent American wife! I*
*have not vacated my role in the kitchen, but I am a woman*
*who finds more excitement in literary adventures than in*

*recipes, so you must be patient and honor this fly in your borsch!*

After thirty years and three children, I had stepped down as the Kitchen Queen and gone into a delicious semi-retirement mode. Now I faced another daunting challenge with this Russian man who began showing subtle signs that he wanted the Kitchen Queen revived and back in action. Was I going to crack the Iron Apron? Was it going to work this time?

### 5 November, 2001

*The weekend in the village was good, full of work and not cold. Olga and her mother are all right and said hello to you. Today is very cold and may be the beginning of winter. The prediction is that November will be colder than usual and we can ski, and nobody knows about December. I know that December will be full of rain in our native Washington state, but more pleasant close to you in front of your cozy fireplace. I love you.*

My cozy fireplace missed him and so did I, but the long, drizzly days had been good for me because I needed to get back to penning and publishing my ghost town mysteries. I knew that once the Russian landed back on American soil, the Wild West would probably get wilder than ever. (Lord, if I'd only known.)

### 18 November, 2001

*Hello Jany. I am so sorry that you could not reach me at home when you called me. It was a 55th birthday of my boss on Tuesday and I was in the office till 11 p.m. Wednesday was a farewell day with my friends, Irina and Sergey. They showed me their photos of the last summer trip to our Lake Ladoga. It was a nice party. They sent very warm Hello to you. My last month here will be very hard and busy, not only because I have a lot of things to finish, but because I must say good-bye to many of my friends and relatives. I will go through this with your help and love. It is one more step to our future life on the Rock of our feelings and faith in God. I love you, Kiska.*

Irina and Sergey. I won't forget them, and I won't forget his other amazing friends and his family, or his daughters and Vadim, and my Russian mom. Saying goodbye to all of them was so difficult. *I love you, too, Val.*

*29 November, 2001*

*Hi Kiska. Would you like to hear the next information?*
*1. I have bought the ticket*
*2. I will depart on the 13th of December by KLM 1396 to Amsterdam*
*3. I will arrive to Seattle by KLM flight 6033 on the 14th of December, 3:45 p.m. local time*
*I will be in Amsterdam for 12 hours. What do you suggest to see in this city? What do you want me to bring from Russia except me? I'm looking forward to see you and hold you soon.*
*With tender feelings, Val*

## CHAPTER EIGHT
### The Russian Has Landed! The Russian Has Landed!
### Again.

*The stars come nightly to the sky,*
*The tidal wave unto the sea;*
*Nor time nor space, nor deep nor high,*
*Can keep my own away from me.*
—*WAITING* ~ John Burroughs (1837-1921)

I am dizzy with joy and flooded with love for this man who now holds me and kisses me with kisses that are better and sweeter than ever. *Oh, Lord!*

On December 20th, 2001, Valentin and I were married (again) in a simple ceremony in a turn-of-the-century chapel on Lummi Island, a small island in the San Juan archipelago where I spent my childhood summers. The lazy, lovely honeymoon days and nights in the small, but elegant Willows Inn overlooking the islands gave us the perfect prologue for the next chapter of our lives.

It didn't matter that it was December and a little bit cold. Calamity Jan and the Russian were warm, cozy and ready to begin the new life together.

And we did.

The days turned into weeks and the weeks into months. We laughed and loved and enjoyed each other, but in spite of so much that was good, the Iron Curtain began to rise up and divide us. When did it all begin again? Trouble and tears sometimes trickle slowly down the silent places of our hearts and our circumstances, and for Val and me, it was as unexpected as a sun dropping beyond a far horizon. I think we both knew, and I'm not sure we could put our finger on the moment or understand the power of our quiet sadness, but once again East and West grew farther and farther apart. Sadly,

the spirit splinters were not healed in the kitchen or the bedroom.

The KGB had moved in once more, issuing orders, making demands, and he wasn't dealing with Princess Marshmallow any longer.

"Valentin," I said one evening after one more argument and roadblock. "We need to get somebody to help us. We can't do this ourselves."

I watched him pull back. Again. His blue eyes darkened, and he turned away and left the house as he often did when things didn't go his way. I knew he would probably find an understanding Russian shoulder to lean on and perhaps a bit of vodka to help him forget his troubles. The pattern had already begun once again, and the only thing I knew for sure was that we had to get help.

Since he refused one-on-one counseling, I set up a relationship seminar with a skilled therapist and although he resisted at first, he finally agreed. We attended two non-confrontational group sessions, and then he backed off.

I remember the list the counselor asked all of us to make, then share with our partner. "List the ten things that make me feel loved and cared for, beginning with the most important." I read Val's list:

1. Cooking
2. Housekeeping
3. Readiness to help me
4. Understanding of man's problems
5. Very good lover

I don't remember the rest, just that I wasn't sure whether to laugh or to cry when we left the session.

"I don't like," he said, and that was that. The counseling ended.

I felt him pulling back more and more, and in response, felt myself doing the same. By this time I was doing most of the cooking, and cleaning and he spent more and more time with his Russian friends. I knew he was missing his homeland, missing his Russian world. I didn't know what to do. I had never had to adapt to another culture (except for a few weeks), so I couldn't possibly know how alienated he must have felt—how alone. I only knew how alone (and exhausted) I felt in this

marriage as he withdrew from me. Author Visson says; "Differences in roles and expectations, common enough between spouses of the same culture, can become major sources of conflict when the couple comes from very different backgrounds."1 "Roles are reversed; the person who at home was a confident, sophisticated host is now a helpless dependent."2

He looked diligently for work; but in spite of his impressive educational credentials, couldn't get employment, so he finally decided to try long-haul trucking. Having an opportunity to tour the country held strong appeal, especially now that the cozy house and marriage held less. The four-week training school took most of his time and energy and by late spring, he passed his tests, got his commercial license and left to go on the road. Maybe we both hoped this would help his nostalgia and give us both time to think and gain some perspective.

I loved him so much, but our time together grew more and more conflicted as the demands, expectations, and arguments grew. "While Russian intensity can be attractive, it does not make for easy living,"3 Visson notes in her book, a book, which sadly had almost become prophetic. While some endearing memories remain, most got lost in the gray muddle of days and months when I simply tried to move on and make sense of what was happening. His withdrawal from me and nostalgia for his homeland crept back into our lives, and I didn't know what to do. Once more, his secretiveness, especially, threw me against that iron curtain and I grappled with my trust issues once again. Because of the secrecy and dishonesty, I wasn't feeling secure about him and our future anymore. This shadow fell across my path during those long days of silence when he was on the road. He seldom called me. I fought against my growing fears, remembering something I'd read by Dr. Jampolsky in *The Art of Trust*; "Your defenses are dams that block miracles from flowing naturally in your life." I didn't want my fears to keep me from loving and trusting this man, yet I didn't want to stumble blindly and stupidly, either.

*We can't lose everything again . . .*

I missed hearing his voice. "Just call me a little more often, Valentin. I want to know you're safe. And sometimes

I just want to hear your voice." In spite of everything, I still loved him and I missed him when he was on the road.

But he seldom called, explaining that it was not convenient to borrow his driving partner's cell phone or use a pay phone. It made sense, so on one of his return trips, I gave him a cell phone. He seemed pleased.

"Will there be a record of my calls?" he asked.

I felt a knot grab my throat and couldn't answer. *Why would he ask me that?*

"Jany?"

"I don't know," I said truthfully. I had only gotten the phone a few days before.

As soon as he left, I called the cell phone company and they informed me that yes, there would be records of all the calls. My gut told me something wasn't right, but my head told me to get over it.

Unfortunately, the cell phone didn't change anything, so I simply focused back on writing and my life, hoping the clutter might bury some of my sadness and concern.

About ten days later he called me as he was passing through on the Interstate, informing me he had dropped *Virginia* off in our van at the company parking lot, and that I needed to get her in the next few hours because of the heat. It was a hot day in June, and he warned me that if I didn't pick her up soon, she would die.

"Virginia?"

"A turtle. I found her in the middle of the Interstate in Virginia so I pulled over and rescued her," he explained cheerfully. "You will like her. Or him. I don't know if Virginia is a boy or a girl."

*A turtle?* I was just getting ready to leave on a three-hour trip for a wedding and weekend in Bellingham with my family. Our van was parked almost an hour off the Interstate in Val's company parking lot, so it was two hours out of the way. A turtle. What was I going to do with a turtle? "Val, I can't! Can you get another trucker to get her? I'm on my way to Bellingham for the weekend!"

"No," he replied. "She will die from the heat in the van if you don't get her right away. Now I must go. Sorry, I'm too busy to see you this time, but I will call and see how Virginia is doing tomorrow."

*Thanks, Val. Thanks a lot.* I couldn't believe this, yet why not? Why not throw in a turtle? This craziness was so like my life lately. I loaded up my things including my dog, then detoured and picked up the poor, huge turtle just in time. Val had left some shrimp for Virginia, but she wasn't interested and the shrimp was rotting and smelly by the time I got there. I tried to remove as much as possible, hoping it wouldn't stink up my car. But no such luck. I drove up to Mom's cottage with a turtle in the trunk and a car that reeked of dead shrimp.

"Hi!" I said to my family, opening up the trunk. "Meet Virginia."

After the wedding and weekend event with the family and caring for the turtle, I returned with Cider and Virginia to my little home nestled in the trees. Cider's cancerous tumor had returned, and I didn't need a turtle to complicate things so I began making arrangements for a turtle rescue organization in Seattle to give Virginia a better life than I could. But Val returned shortly after that and promptly took her to my daughter's ten-acre farm and dropped her in their pond.

I wondered if Virginia would survive.

And I wondered if I would as well.

During those stressful days, my mother had a major stroke. I traveled back and forth to the hospital and later to rehab in Bellingham, my little sheltie by my side. Cider's cancer worsened and by mid-July I knew I had to put her down so that she wouldn't suffer. It was a difficult time for me. For almost a week I tried to reach Val on his cell phone but he didn't return my calls, so on July 13th, I took her to the vet and did what I had to do. I held my little friend of thirteen years in my arms and cried as she peacefully left me.

And no one was there to hold me that night of my grief. *Goodbye Cider. I will miss you so much. Thank you for giving me your dear, devoted little life all those years. I never had a better friend than you . . .*

Val loved Cider too, and although he didn't wish to talk of it, I knew it was hard for him when he returned and realized she was gone.

"I tried to reach you, but you didn't return my calls." I wondered if my words sounded as hollow and empty as my heart.

He didn't respond.

"Val?" I said just before he left on the next road trip. "We need to talk."

I think he knew. He sat down at the dining room table across from me, the blue eyes darker than ever and holding my gaze now.

"Do you want to go back home to Russia?" I asked. My eyes filled because I already knew his answer.

"Yes," he said quietly.

We both stood up and walked into each others' arms and simply held each other.

"You were the best of my three wives," he said finally.

I didn't respond. If it weren't so tragic and if my heart wasn't breaking, I might have laughed. *The best of the three.*

He told me he had been missing his family and hated leaving his mom alone. He also said he didn't like his job and dreaded the winter months of trucking over the icy mountain passes. Of course there was so much more, but he couldn't express that deeper part of himself. That part of Val had already begun to leave me months before anyway. "I'm sorry, Jany."

Author Lynn Visson says, "Intimate involvement with two cultures can result in a richly bicultural life. It can also create a person who feels homeless in both countries."[4]

I guess that happened to Val.

That afternoon we took each other's hand and walked down the woods path together, knowing nothing would ever be the same again.

Nothing ever was.

In August I paid Val's cell phone bill. There were very few calls to me, but many to his Russian friends, and most to Svetlana in California. *And that was it.* During the days of silence including Cider's last days when I had tried to reach him—needed him—he had been communicating with her once more.

"Yes," he said, when I handed the record of the cell phone calls to him. "On my way through California I stopped at their home and met with P'yotr to discuss some business we might do in the future. Of course, Svetlana was there. I spent a little time with them. Yes, and Svetlana and I talk on the phone sometimes, too."

According to the phone records, they talked a lot. On the deepest level, I guess I wasn't completely surprised. Sadly, all of this happened during those difficult days when Mom had her stroke and Cider was dying—days when I wanted and needed his support.

He wrote me later from Russia:

*All my life I have had many friends—women, but only friends, not lovers. It was very surprising for many persons, even for my real friends. They could not understand me, but sex was not the main for me. You, too, didn't understand this. I was grieved of your control of my calls and the groundless jealousy. You didn't understand these things, and I couldn't explain it for you. It was a pity. Sorry.*

Yes, it was a pity. I'm sorry he couldn't explain it for me, too. From the beginning of our relationship, he knew I enjoyed and encouraged the connections with other Russians. It was only when I felt his gradual pulling away—the secrecy and dishonesty—that I became uneasy. I knew he was not having sexual liaisons, but when a wife becomes an outsider, then this solace and bonding with other women can become a dangerous journey, no matter how innocent the friendships might be. Because of this, I don't believe that my feelings of insecurity were groundless. While I do take personal responsibility for my actions and reactions, especially when it came to my own trust issues, I don't blame myself any longer. I did the best I could under the difficult circumstances. Once trust is broken, it takes a lot of time, work and love to heal the damage. That concept seemed foreign to him, perhaps part of our cultural disparity? "Forgive and forget," he said to me more than once and with impatience. Val went on to say in that same letter: *Now I know that we could be the*

real friends if you would be more tolerant of me—the Russian man.

I tried.

We both tried to make our last days good ones, though it wasn't easy.

We celebrated my 65<sup>th</sup> birthday on the Seattle water-front, and made a trip to see Mom, who was recovering well from her stroke and now living with my brother and his wife. During Val's final working days, I often drove to Seattle to visit my close childhood friend who was dying of brain cancer.

During this time I also e-mailed Valentin's close friend, Fedor. Fedor had tried to dissuade Valentin from the decision to leave me, urging him to fight against his returning nostalgia. I wrote to him, thanking him and his wife for their support.

*Dear Fedor, I loved him so much, but I don't believe Val can connect—truly connect with a woman. He wants this, he wanted it with me and maybe his wives before me? But he can't. The thing that he seeks (as you said in your e-mail to him) when it becomes his—he cannot take and receive it into himself, so he will always seek that which he does not have. He will always want that thing (person) which is beyond him. When that person becomes reality, I believe he cannot take her and become intimate with her because this brings fear to his soul. We have talked. Maybe he will share this with you. I wanted counseling (help) for us because of course there is more, but he won't do it. He runs from closeness and intimacy. Maybe he can't help himself. Maybe he can. Either way, he loses me now, Fedor. He has lost a woman who loved him deeply, but I cannot go through such things again. You, good friend, will be there for him because he is going to need you. I am thankful for you and one day, perhaps, I will meet you and your wife.*

*Jan*

Val wanted to spend our last day with the grand-children at the ocean, so we piled all six of them into the van and drove to the Washington coast. It was a bittersweet, yet beautiful, day in so many ways and I won't forget it. "Val is my best friend," my little Russian

grandson told me one day after Valentin had left us. I watched them walk hand-in-hand that day on the beach, and I knew he meant it. I still have some wonderful photographs to remind me, and those reminders still bring tears.

On a gray November day we stood in the airport holding each other, saying goodbye. Through the tears, I watched him walk away, knowing I would probably never see him again.

"Goodbye, Kiska!" he called as he moved down the escalator, throwing me one last kiss. His eyes welled up, and I turned away.

Through my fog of tears, I found my way to the parking garage and got into my car. *It is over. It is really, really over, isn't it?* I thought my heart was going to be torn from the deepest place in me. My anger and grief felt bigger than my strength to keep everything together and move on. But I would move on. I had done it before, and I could do it again. Sobbing, I pulled on to the Interstate and headed home.

I remembered something I'd heard once; *"Grief isn't a sign of weakness, nor a lack of faith. It is the price of love."*

*Okay . . .*

I cried out, asking God to help me get through this terrible time, and He did.

Suddenly, unexpectedly, I found myself making a detour off the Interstate. My childhood friend of 60 years was dying and her daughter had brought her home so that they could be together during her final days. I drove to Rhonda's home in a suburb below Seattle. Their load was so much heavier than mine. I wiped away my tears and spent the rest of the day and evening helping Rhonda care for her mother. I needed to be with Lynene that day far more than they would ever know. I stroked her forehead with a cool cloth, reminiscing and recalling the crazy, carefree years when we dug tunnels in the vacant lot next to her house, and kissed boys in the chicken house. Lynene moved out of the chicken house (with the boys) faster than I did. I laughed and told her it was because she didn't have to stuff her bra with toilet paper like me, but I knew it was because she was the prettiest girl in the neighborhood. And the sweetest one, too. Her smile told

me she heard every word, and her tears told me deeper things. As I stroked her smooth, pale skin, I still saw her beauty, even at the cruel edge of her departure from this life into the next.

*Be the wind beneath my wings sometimes, dearest friend . . .*

And I cried again and drove home to a little house that felt colder and emptier than I had ever known.

Valentin called me from the St. Petersburg airport less than twenty-four hours later.

"Jany, I am coming back!" Tears filled his voice. "I have made a terrible mistake! I will be returning on December 20th. I am making the reservation now."

"No!" I cried out, gripping my phone. My soul knotted as I spoke the words that sealed our final days. "No, Val."

*No. No . . .*

The phone went silent.

"I am so sorry, Valentin. So sorry."

"Please consider this, Jany. Please think very seriously and talk to God about this decision. Please pray!"

I told him I would, but I already knew that God (through my own senses and circumstances) had probably already been showing me the answers for a very long time. *I am so sorry, Valentin. So sorry . . .*

Still, I prayed as I walked along my country road day after day. This was my place of prayer and these were the times when I felt closest to my Creator. *"If you mean for me to take him back, you have to show me. Otherwise I simply can't. No matter how much I love him, I just can't."* The December winds blew dead leaves along my path and against my heart. *"God of the Universe, if you don't show me in some miraculous way, then I will use what's left of this brain you have given me and make the right decision."* The dead leaves at my feet and along my path remained silent, giving answer and paving the way toward what I knew would be my coming spring. A gentle peace held me warm against the cold, and I simply knew.

I called him finally. "Dearest Valentin, I am so sorry."

And so it was over.

On December 20th, 2002, I sat down by a dying fire and cried. It was our one-year Anniversary (second time around) and my friend, Lynene died today. It didn't feel like Christmas, even though my wonderful children and grandchildren surrounded me with angel love.

I gave the Eulogy at Lynene's service. Since I wasn't Catholic, the priest asked me to write down the words and give them to him for approval first. I explained that I couldn't do that because everything was going to come from my heart and I didn't know what my heart was going to say yet.

He wasn't sure what to do about me.

Lynene must have had her say, because he finally consented and I gave her tribute in the best way a best friend could. "You are the wind beneath my wings," filled the church with the music that came from a pipe organ and from the skies. We all walked away with our tears and our memories and moved on.

Everybody moves on.

I guess the Russian, just like the Priest, wasn't sure what to do about me, either. So Valentin moved on, too.

I wrote a letter at Christmas, sending love to Valentin and his family. *"I didn't get a tree. I guess I didn't need one since ours from last Christmas is still outside leaning against the side of the house. I think of you every day, keeping you close in my heart and prayers. In spite of everything, we had some beautiful memories."*

Val loved that Christmas tree so much he didn't want to dispose of it, even after it turned brown and began to lose its needles. It grew on me after awhile, too. Sometimes that and other quirky little mustard-like memories still make me smile.

In February, the divorce became final.

I moved on toward a new season of my life.

"Yesterday is gone. Tomorrow has not yet come. We have only today. Let us begin."

Mother Teresa.

The morning of love was over.

# Chapter Nine
## Life's Late Afternoon

*Poor cluttered hearts—starving for the emptiness that
makes fullness possible.*[1]
—Macrina Wiederkehr

*18 March, 2003*

*Hello Jany. Thank you for your sincere letter which I
got yesterday. I didn't send you a letter because it is very
hard to express my feelings. We told each other so many
things already. Maybe it is enough. I simply love and miss
you so much. I am deeply sad and sorry that our marriage
didn't work out for us. When I came back home I wanted to
come back to you and try one more time. I sincerely
wanted, but you didn't want. Now it is very hard to
understand that we both have to move on with our own
lives.*

*I loved and love you. I remember many good things we
have had together. Take care of yourself. Best wishes to
Ethel and the family, and the beautiful Washington State.
Say hello to my best friend, Brooks. Tell him that I love him,
too, and hope to see him someday again. I am very glad
Virginia has survived, but sad that he is single as I am. I
hope God gives us many peaceful years and someday you
will invite me. Welcome to Russia any time you can and
wish to come. God bless your family.*

*Love, Val*

*Would you like to stay in touch with me? I love you.
You are my real friend.*

We did stay in touch.

It turned out that Virginia the turtle was a boy. He
lived on for two more years and then one day my son-in-
law and granddaughter found him on the road. They took

him back to the pond, but that was the last anyone ever saw Virginia. Did he try to find the greener grass or deeper pond on the other side of the road once more?

I sent Val a large parcel of natural vitamins, a book and some medical papers he needed. *"Take care of yourself and be healthy, Val,"* I wrote him. *"Let's both try to be wiser than Virginia."*

*28 August, 2003*

*Hello Honey. Thank you for the useful book and the medical papers. I appreciate your care about my soul and body. I am quite well and try to be wiser than Virginia, but, maybe it is in vain. The summer holidays are soon over. I miss you and the family.*

A year later Val became a grandfather again.

*August 8, 2004*

*I am the granddad twice now! Katia gave birth to a small girl, Maria-Masha on Friday.*

We stayed in touch by e-mail, but our connections became fewer as the years passed. I told him that the fourth book in my *Ghostowner Series* for young readers had just been published and that I had been invited to do a television interview in Reno for a PBS pilot project. I also began doing more school presentations and freelancing for magazines. *Arizona Highways* bought the most recent article profiling my father who journeyed by pack mule into Monument Valley in the late 1940s and captured spectacular photographic images of a Navajo family in their native setting. The magazine sent me on assignment to find the family, hoping I could fill in some of the missing pieces. During a fierce dust storm, my brother and I ventured into the same back country sixty years after Dad's journey, finding some descendents who did, indeed, help me fill in those missing pieces for the story. I stood with my brother near the Yei Bi Chi rocks, shielding my eyes against the burning dust and thinking about those amazing people and my father, thankful we were

traveling by car instead of straddling a mule or hovering under a shade house.

The following spring, Val began having some serious health issues.

*15 April, 2005*

*Hello JANY! How are you doing? I am still alive, but was sick for 45 days with my stomach and liver. They gave me a handicapped status with the possibility to work not the whole day (six hours a day) for a year till the next March. Then I will have to take another medical test. I lost seven pounds, but I am strong with soul and spirit. Thank you GOD!!! Because of the above—I sold my flat and bought a studio for Mom. We will live together until September, then I decide to move to the South, to the town-resort Sochi on the Black Sea. It is about 20 miles from Georgia.*

*My love to everyone.*

Deeply concerned, I asked Val to write and tell me more. Stomach? Liver? It didn't sound good.

I told him that our little Brooks from the Ukraine had developed a fast-growing cholesteatoma in one ear. Cholesteatomas eat away bone and the cochlea and the doctors had no idea how much bone remained between the ear and the brain. After diagnostic imagining, the doctors at Children's Hospital in Seattle scheduled the surgery, but couldn't operate because of his high fever. They put him on antibiotics, telling my daughter and her husband that they feared most of his bone, including his ear drum, had been destroyed already. The doctors went on to explain that it was probably too late to save his hearing, but that when he was a young adult, recon-structive surgery might give him back some hearing.

Everyone prayed for a miracle for this innocent child who had been through so much already. He was sixteen months old and weighed less than fifteen pounds when my daughter Julie, and her husband found him in the Ukraine in 1999. My son-in-law had been part of a mission team to orphanages the year before and learned about the plight of so many children there. Brooks couldn't even hold up his head and struggled with a

serious heart defect, eye problems and hepatitis. Most of this was the unfortunate result of being abandoned and left in a hospital, then an orphanage for the first year-and-a-half of his life. Julie and Skip knew all this when they adopted him and brought him back to the waiting, excited arms of his six sisters! Even though he had since gained weight, had two successful eye surgeries and happily adapted to his well-earned *Little Emperor* role, young Brooks still had a serious heart problem and didn't need one more health issue to complicate his life.

And Val didn't either. I hoped I would hear from him soon, but knew he was probably in Sochi looking for a house.

*10 August, 2005 St. Petersburg, Russia*

*Hello Jany! I have returned from Sochi. I'm so SORRY about Brooksie. Maybe it was (and is) something wrong with his feeling of pain from his birth. And you need to ask him very often (even daily) about his health-feelings. I'm praying. The trip to Sochi was not bad, but I did not buy the house. The foundation-basement was wrecked during winter rains and I discovered it. I dissolved the contract with the real estate and began the seeking again. Then I will continue it in September. Mom, Katia, Vadim and Masha are in the country now. I visited them this weekend. It was Masha's first birthday on 29th. The weather was and is warm, but a plenty of rains now. I am still working and do repair in my flat after the working days and on weekends. I am very tired, but alive.*

*I miss you, your family and America. The life here became harder. But God help me and I thank HIM.*

I wrote Val and told him about our miracle. After Brooks' fever subsided, the otolaryngologist pulled away the dried material and couldn't believe his eyes. The cholesteatoma had begun to resolve itself and the eardrum was actually repairing itself. Astonished, the doctor told my daughter that such things don't happen. "The God of the Universe has done this!" he said over and over. "There is no other explanation. None!" Two weeks later the bone and eardrum were 90 percent restored, and there was no

162

sign of the cholesteatoma. Shortly after that, Brooks' hearing tested in the normal range.

*25 August, 2005*

*Hi Jany. I am so happy for Brooksie. Thank you the FATHER!!! My best wishes and congratulations to Julie and Skip.*

My heart could have burst with the joy of this miracle, and I knew Val felt the same. We continued to stay in touch, talking about his health, our lives and families, including a few milestones. We celebrated my mother's 95th birthday, both of my daughters' 25th wedding anniversaries, and my 50th high school class reunion. My son had also become a commercial airline pilot, which opened new doors, giving me free flights all across the country. These were good days for them and for me.

I continued to inquire about his health, asked if he had found a house in Sochi yet and if his mother was going to live with him or stay on in the flat in St. Petersburg.

*9 September, 2005*

*Hi Honey.*
*I am very glad that Ethel is so healthy. It is great. Mom is okay too and do a lot of housekeeping every day in our small studio. We sleep in one room, she is snoring. It is very uncomfortable, but it is my choice. I need money for my Sochi project. I have found one small house-dacha, but the price is very high for me. I negotiate with the owner and hope to decrease it. I will go to Sochi at the end of September and will be over there all October. I love the cover of your new book. It is very expressive.*

*Dear Jany, what do you think—maybe, it is time to write a book about us, our love and real life? You are a good writer and I will help you. It can be very interesting story. Do you think so?*

A book about us? Our love? Real life?
*Dear Lord God of the Universe . . .*

In December, he wrote and told me that he had been sick again with his stomach and liver and was going to have surgery. *The name of the infection is Ecchinococcus granulosus. I will lay to the hospital on January 10th. I hope the surgery to remove cyst from the liver will be successful. God is helping me. Please, pray about me.*

"Oh Valentin!"

I learned that Ecchinococcus granulosus is a parasite and is most commonly carried to the liver when humans become infected by swallowing eggs in contaminated food. Apparently the cyst can be growing slowly for ten to twenty years. In the United States, the disease is rare.

On January 13, Val had the risky surgery on his liver. His friend, Leo stayed in touch with me by e-mail, informing me that the three-hour operation was successful. He also sent pictures over the Internet of a thin, but smiling Russian. By this time, the doctors informed him that he had another cyst on his lung.

The Ecchinococcus parasite usually attaches to the liver, lung or brain, and while the surgeries are very risky, if the cyst shows up on the brain, it is inoperable. I felt completely helpless and deeply concerned.

*12 March, 2006*

*Hi Jany! I am alive and not bad now. Thank you and your family for care and praying. I will be with the drainage tubes from my liver till May and maybe longer. At the end of March the Medical Commission will give me the new handicapped status. Then I have to start to work or to retire. Now I use the third dose of Albendazol and in September we (my physician and I) will decide about the surgery on my left lung. I hope everything will be okay. I am strong with my soul and spirit. Thank you God!*

Valentin! You are so brave! I try to focus back on my family, writing and school presentations. But thoughts of him stay close and sometimes it's hard to stay on task. I realized I had gradually closed a lot of doors between us, but now as the health issues emerged, I found so many memories returning.

*10 April, 2006*

*Hello Jany! Thank you for care. I decided to retire later and now I am working half time. It's not hard for me and the only way to make some money for living, because my pension will be only about 80-100 dollars. It is a sad reality in my country. But I am strong enough with my spirit and soul. My health is better now and I hope to move to Sochi in October. I am busy now with my taxes, invalid pension and cleaning my liver every day. But I hope (and want) soon to help you begin to write our story. Mom is okay.*

Our story? The thought jars me once again. *I'm not sure I can do this, Val.* I had put our love letters in a box and didn't know if I could go through all that again. *Ten years. Lord God, we had so many dreams. Why dredge everything up again?*

*9 July, 2006*

*Hello Jany. I came back to the office two days ago. I am quite well and bought a small house in the mountains. It is eleven miles from the center of Sochi and the Sea. The place is very similar as Cal's was. I am very glad, because the prices are up over here. How is David? Did Dasha connect with you? Stay in touch. Say hi to the family.*

It was great to learn he finally got his house near the Russian seaside. I told Val that my brother David was doing great. David, also the pastor who had married us, had a serious heart attack but, thankfully, got help in time and recovered quickly after bypass surgery. Shortly after that, Dasha, Val's 21-year-old daughter came to the United States on a student exchange program and took some extra time to visit with me and our family. My children and grandchildren loved her, and we're already looking forward to her next visit.

*"Thank you so much for my new daughter, Val,"* I wrote him. *"She is wonderful, and we've become so close in such a short period of time. Sometimes we find unexpected*

treasures in the dust and sadness of our lives, don't we? Dasha is a treasure. Thank you for her."

*Later, Dasha wrote me from Moscow:*

*I do not know if you know that my full name is DARIA, a Persian name. There was a Persian King Darius and in Russian, the first letters D-A-R means "Gift." You are my Gift presented to me by your marriage with Dad. Although I have little experience, I do understand your feelings and would like you to know that I love you a lot. You are the person whom I have known because of my Dad.*

*16 July, 2006*

*Hi Jany. Thank you for care. I am very glad that David is much better. I am okay too. Mom is pleased about Sochi, but I don't know if she will want to leave her cozy flat. I began my tests. My doctor will come back from the holidays in August and we will decide what to do next. If the tests are good I will go to my new house in September. I am sure God is helping me. How are you doing? Take care and stay in touch.*
*My prayers to the family.*

I know he wants to get through the tests and begin his new life in Sochi as soon as possible. My prayers stay close to him. My heart does, too.

*9 August, 2006*

*Hi Jany! I am quite well. All tests are over and the surgery on my left lung will be on the second half of September. The tests are not worse and not better. All the doctors recommend to cut the cyst now. I am sure everything will be okay with HIS help.*

I sent a card and some favorite country CD albums to cheer him up. I wanted to help if I could and talked to Dasha about going there to be with him. She didn't feel it was necessary. It's probably a good thing I didn't, and I'm sure she knew it. I'd just be underfoot with my pathetic

Russian speaking skills and inability to get around by public transport on my own. Getting on and off the buses, trains and subways in Russia without getting squished, lost, or run over had been nothing short of a miracle, and I wasn't so sure I wanted to tackle it without my interpreter, who would be recuperating in a hospital.

*14 September, 2006*

*Happy Birthday Honey! Many years of active and healthy life to you. You gave me so much spiritually. Thank you. My hugs to Ethel and my memory to Cal.*
*Be in Peace and Love. Your Valentine*

*PS Thank you for the musical gift. I will go to the hospital on September 20th. Thank you for warm words and for having Daria. She is really special person, better than her dad.*

I thanked him for the birthday wishes and the beautiful card with roses. If I gave to him spiritually, maybe it was the way love connected us again and again and again. I loved him so much and in spite of all that went wrong, and I guess he knew it. Dr. Jampolsky in his book, *The Art of Trust* says: "Offer love, and it will come to you because it is drawn to itself."

The words flew into my mind, settling finally in the center of me where reason and logic and mystery lives. Through all these years, Love had been playing out in our lives, hadn't it? Our Creator had been there and the power continued to hold us, draw us, energize us. And heal us. Dr. Jampolsky goes on to say: "There is a way of being in life that puts the ability to have peace of mind into the domain of your choice. It begins with believing that every situation, regardless of whether it is to your liking or not, holds the opportunity to learn of love."

I think that happened to us.

*You gave me so much too, Val.* I will never fully understand the power of friendship and love, the power of stubborn love that spans oceans and cultures and common sense. But maybe I am beginning to understand the

miracle of it and how connected we are to each other and to God. Maybe after all these years, I'm getting it.

*. . . and in the pieces I found who I was.*

*God, thank you for helping me find the pieces of you in the pieces of me, because I think that's what you've been trying to show me for so long. I realize more than ever that you're not just "out there," but you're "in here"—in me, too. As my poor cluttered heart has cried and called out for help, you have been trying to show me how to lower my voice and find you closer than my heartbeat. You are my heartbeat. You are Life. My Life. Thank you so much for this knowing that has come so late in my life. Thank you for the brokenness, for the emptiness that has made fullness possible. Thank you for this peace.*

*Be with Val, Father. I'm sending the love now and trusting that he feels and knows he is being held very close. I hug you, Valentin Anatolyevich Gudkov . . .*

*Do you feel it, you stubborn, impossible, dearly loved Russian man?*

On September 27th, Val's friend, Leo, gave me the good news that the surgery was successful and that he was recovering well.

*Thank you, God.*

Val and I continued to keep in touch. He worked part time in St. Petersburg until he took his follow-up medical tests in January. Thankfully he passed them and moved to Sochi, settling into his new home where his small garden waited.

*5 April, 2007*

*Hi Jany. Thank you for message. I am okay but still very busy with the fixing the house and the gardening. I like it, but it takes me several months or many. I want to take two red kittens in two months. Today I visited the yachting club. They suggested me to be a member of the crew. I will try. The weather is not very warm, only 50 F, but the orchards are in full bloom. Mom is okay and still in*

*our flat. Dasha will come for the holiday in July, Katia with Masha at the middle of July, and Vadim at the end of July.*

*Welcome to Sochi. Say hello to everyone. I miss your great family and YOU.*

*With Love, Val*

Since Val didn't have e-mail access from his country house in Sochi, our connections became less frequent. The days grew long and difficult for me when my 96-year-old mother began to fail and needed more care. I lost her in August, and my heart still grieves for her. I miss her so much. Not long after that, my daughter and her husband and five of my grandchildren left on another mission, this time to Ghana, West Africa for a year.

In January, Val returned to St. Petersburg to visit his mom and get follow-up medical tests. His tests went well and he returned to Sochi. In February I sold my little house and moved into a peaceful water-view condominium overlooking the harbor and snow-capped Olympic Mountains. During this time I was also diagnosed with breast cancer.

Breast cancer! The excitement of moving into my new home hit the skids when the news shattered my plans and the doctor scheduled surgery immediately. My daughter drove up from Oregon to be with me, and while this ill-timed interruption jolted me, thankfully the tumor was small and had not spread. Friends and family gathered around me, and my brother flew in from Phoenix to orchestrate the move and stay with me for as many weeks as I needed him, all of which helped make the transition so much easier.

*5 March, 2008*

*Hi Jany. It is a pity that you leave your cozy house, but it is good, because the life in a condominium is easier for a single person. The same with my house—I have to take care of it and the garden all the time, to warm it with woods from October till April and many other problems. The prices become very high for food and other things in Sochi. But I love the climate and Nature here. I feel healthier over here*

*and happy. My best wishes to Julie, Skip and the girls. I am praying for them.*

I realized that I'd forgotten to tell him about my cancer surgery, probably because it was a crazy time for me with the move, surgery and follow-up drug treatment. I called him and he was glad my situation had turned out so well.

I'm enjoying my new home overlooking the bay so much and finally feel inspired to begin writing again. My two-mile walk around the bay each morning gives me peace and stirs that Gift deep inside me. Gulls and herons cry and drift over the tide flats and on the currents, and I'm part of this now.

I am part of something so powerful and amazing, and I have only begun to touch the brilliance of it. *But I have begun to touch it.*

*24 April, 2008*

*Hi Jany! I am alive and healthy. It is warm over here, 70-80F. The orchards have bloomed already. I work in the house and the garden a little bit, walk in the mountains sometimes and on the beach weekly. Mom is okay and sends her love to you from St. Petersburg. Dasha will come here in May for four days. I am so glad. I am very glad that you have such nice picture from your deck. It is great to see the sunsets, the sea with yachts every day. How are you doing? How is the Family? I miss YOU and them a lot. Sorry for not often connection.*

*With Love and the great memories. Welcome to Sochi*

Great memories? It had been almost eight years since we said goodbye. There were some great memories, but there were some I wished I could forget. Time helped erase so many of those, but time also gave its Gifts. In spite of so much sadness, I think we walked beneath the shadow of a rainbow.

I'm seventy-two years old now, and Val is sixty-three.

I was sixty-two when I met him at the airport over ten years ago. It seems like yesterday. Calamity Jan and the

170

Russian. East meets West. Little did we know that *doing a risk* would change our lives forever.

> *Sometimes, though, it is in the winds of change that the poor cluttered hearts find*
> *their way into those quiet, empty places of our lives where loss and broken dreams lie*
> *in pieces at our feet. It is then—and perhaps only then—as we are bending low, that the*
> *pieces begin to come together and form something far more beautiful and enduring than*
> *we could have dreamed. This is the Miracle.*

> *When you truly possess all you have been and done, which may take some time,*
> *you are fierce with reality.[2]*

In September, we started talking about the book, and Valentin began to open up to me because I asked him to. If I was going to write our story, there were some things I needed to know, some threads I needed to untangle. He began writing letters.

*26 September, 2008 Sochi, Russia*

> *I will try to express my feelings and explain my actions honestly. Maybe something will be unpleasantly for me, and for you, too. But, it is better than to have it inside.*
> *It was many years ago, in the 1960s, in the university during the military classes. We—my friend and I dreamed to finish our lives somewhere near the sea or in the mountains in a small cottage. He is the alcoholic living somewhere in St. Petersburg and I am living in the beautiful mountains near the Black Sea. It is great, but I am not satisfied and peaceful. Why? Because I don't have a real friend near me, with whom I can share most of my thoughts. Not all, because some of them must be, to my mind, absolute private.*

He talked about the problems we had together and why; that if I could have been more tolerant of him—the Russian man—that things might not have turned out the way they did.

*I was successful all of my life. I was born in a good and not poor family, studied in a very good English school, graduated from two very famous universities, traveled a lot by yacht and car and never dreamed to leave my country. I loved Leningrad and Russia. But one day Irina showed me the photo of not very young, but very pretty lady—of you, Honey. And our story began. You know the beginning and the end of it, but you don't know about my real feelings and thoughts.*

*At first my interest was only of the new people and place. You showed me a lot. I met your children and relatives and loved them first. I enjoyed our life and loved your country and the American people. I loved you, my Darling later, when I began to feel that you were the real friend to me.*

I held his letter in hands that were shaking now. *He loved me <u>later</u>?* I e-mailed him, unsteady fingers flying across the keyboard. "Valentin! What did you feel when you met me for the first time at the Seattle Tacoma Airport?"

His e-mail reply stunned me.

*First I loved the girl with the Texas hat from the photo. Then I saw a small woman in the airport,* he wrote. *I felt nothing.*

*Dear God. So that was it . . .*

I drew a long, slow breath as the cold reality wrapped itself like an ice blanket around me. *He didn't love me then. Not even when he asked me to marry him. Not even when he said "I do" in the meadow by the creek on that warm summer day nine years ago.* I felt numb as I slipped on my jacket and walked around the bay. I hoped the salt air and wind would clear my mind and let the tears explode from behind my aching heart. *He felt nothing.*

This explained so much, didn't it? Now I understood why I felt such emptiness in the beginning. Animation. Charm. And coldness. All this because he didn't feel anything. It simply wasn't there. *Oh, God.*

I read his e-mail again when I returned from my walk, feeling more sadness than I had felt in a long, long time.

He felt nothing, yet he married me. *Valentin, how could you have done that? How could you have married me when you didn't even love me?* At that moment, I knew I should be tearing up his letter and stomping on the memories, but all I could feel was a terrible sadness weighing me down like a huge rock.

I had asked him to be honest if I were going to write our story. And he was. Although I had found my peace, I had no idea this unexpected truth would still have the power of a sudden, cold Siberian wind against my soul.

In his letter, Valentin went on to say that as he got to know me and my family, he began to care for me, but it was only when I came to him in Russia, that he really loved me.

*I wanted to be loved,* he wrote. *I had not been loved before, except my relatives. Later, when you came to Russia, I loved you! Maybe it was the influence of my great, but poor native country.*

In Russia? One year after our divorce? I continued reading.

*When I returned for the second marriage, I really loved you. I wanted to stay with you until the end of the life because I loved you and the lovely America. You became more beautiful to me than the girl in the picture.*

I scarcely slept that night. My mind backed up and played reruns on every single memory. My own love for him during our courtship and marriage had clouded my vision, blinding me to the truth that he didn't love me in those beginning days of our courtship and marriage. And yet, should it have been a surprise? On the deepest level, I had always known something wasn't right. I remember having second thoughts after he had asked me to marry him, after he had returned to Russia to prepare for our new life. His tender, poetic letters and declarations of love hadn't matched our reality. My gut told me something was wrong.

Over the phone and in letters, he insisted he loved me more than ever, and I believed him. Wanted to believe him. Why didn't I trust my gut? How naïve I had been.

*I lied to Irina and you when I first came,* he went on in his letter, *but it was a lie in the name and hope of future love which I wanted so much. I'm sorry, Honey.*

Dear God, I was cabbage soup right there in the airport from day one.

I know there was so much more playing into this sad, destructive dance but now I understood a little more of what happened, and why. Calamity Jan and the Russian were, indeed, headed for the cliff. Caught in this hollow, loveless place during those first weeks and months of our marriage, I quickly found myself growing more and more insecure, trying to hold on to (control) what I didn't really have. I didn't like his rudeness, dominance and the growing secrecy and yet I felt helpless. I couldn't understand his wish to shut me out and exclude me from his phone, e-mail and personal connections with others. *"I have my partners and my friends. You are my wife,"* I remember him saying. It was nearly impossible to be a wife, especially a tolerant one, when I felt I was married to a stranger.

Wedded strangers. Who would have known that Valentin Gudkov and Calamity Jan would become one more statistic, thrown like Matryoshka Dolls against the dreams and dances of the Russian-American lovers before them?

One Russian woman, a friend, said to me; "You just don't understand the Russian man."

Another woman, the author of Wedded Strangers who wrote and gave me permission to quote passages from her book added; "I'm sorry that your Russian-American marriage didn't work out; the linguistic and cultural differences, let alone personality differences, can be enormous."

Both women were right.

*1 October, 2008 Sochi, Russsia*

*After our second marriage ended I came back to Russia, to my native city, to my family, to my friends, but not to myself. Everybody was glad to see me and I was glad to see them at first. Mom and the family were glad to have me nearer, but didn't like our divorce. My friends*

174

*considered me the fool for coming back here. The city was gloomy, dirty and not my native Leningrad now. And Russia was not lovely to me. Everything seemed not good to me. It was the terrible time for me. Financially I was not bad because I got a good job in an industrial company. I visited concerts and performances with my friends, skied a lot, but spiritually I was lonely. I could go back to the United States and move to another state because my company wanted to hire me again in spite of my divorce. I could live and feel better in the United States than here, but I was scared to become more lonely in America than here because you didn't want to be with me and didn't call me back. It was terrible time. I felt bad and couldn't get used to Russia even during two years or more. Then the pain became smaller. I was calming down spiritually. I was alive and decided to move from St. Petersburg to the South. I moved to the mountains near the warm sea, but I am still single and lonely.*

I held his letter and cried. Although his words were hard for me, they were important and helped me gather up some of the lost, fragmented pieces I needed to begin to put our story down on paper. I realized that Valentin needed to look at the manuscript and feel okay about how the book unfolds, as well as contribute some things that only he might be able to offer. I've used his letters to frame this story, because they are amazing and I can't possibly imagine any other way to tell it. This dredges up every conceivable memory and some of the narrative isn't always easy for me, but I'm doing it anyway. I try to stop writing after sunset so that the memories won't invade my dreams and wreak havoc on my sleep. On a good day, though, I'm laughing or at least smiling a lot.

He got a kitten and named it Cider. I'm definitely smiling.
We're now talking about seeing each other again so that we can tie up some loose ends in the book and maybe, tie up a few loose ends of our own. I am hoping he can come to my beautiful condo by the sea, but he wants me to come to his dacha near Sochi in the south of Russia.

175

*Kiska! Don't be afraid. My small cabin is more comfortable than it was in Volochyok. The kitchen and the bathroom with <u>flush toilet</u> are on the ground floor, but they are without heating. Because of that it is more comfortable to visit me during the warm season. I heat the first and the second floor with wooden stove. I sleep on the second floor and use the beautiful (your lovely) slop bucket at night. Welcome to my village, Jany! With Hugs, Very Bad Boy*

We begin discussing the possibilities of connecting again, as well as the problems we might have getting a visa. Will Immigration trust Calamity Jan and the Russian one more time?

Will Calamity Jan?

*Oh, good grief.*

As I write, I think about the dream he had just before he met me; the dream that compelled him to find Irina so that he might understand its meaning: *"I was walking beside the water, and across the water someone was coming toward me in a great mist—as a fog upon the sea. The hair was long and blowing as in a wind. I was pulled toward this person and knew I must reach this. The dream returned and would not leave my mind."*

Does he wonder still who was coming toward him? I will ask him if we meet again.

I'm watching the mailbox now because he told me he has written me a long letter and that he had another dream.

# CHAPTER TEN
## Red Flags and Miracles

*Ah, when to the heart of man*
*Was it ever less than a treason*
*To go with the drift of things,*
*To yield with a grace to reason,*
*And bow and accept the end*
*Of a love or a season?[1]*
Robert Frost

"Didn't you see all the red flags, Mom?" one of my children said to me after the marriage had ended for the second time.

*No. Yes . . .* I replied silently. *Yes, and I love red. Red is filled with passion and warmth. It draws me.*

This unknown culture and life drew me. You, Valentin Gudkov, drew me.

My children—your mother is still a vital woman who refuses to grow old without ever having lived and loved completely. Your father tried and I tried with him, and it didn't work. The miracle was that from this futile, yet honest attempt to find love and build a life during our thirty-year marriage, the three of you were born. And from you have come priceless treasures, including fourteen amazing grandchildren!

This was a miracle, but only the beginning of miracles.

The red flags waved and dear God—dear children—they brought me an ex-communist from a land and a culture that would shake my foundations (and yours!).

Life always gives us choices. In so many ways I have been shaped by my past. It's taken years, and now that you are raised and I've crawled up through the tangle of circumstances, I know that the murky water and obstacles

have strengthened me as I've made choices that have changed my life.

I cannot sit idle on the porch of Life's Late Afternoon. I may be in my 70s, but if there is any *elderly* in me, it is only my skin. This time-worn, well-earned skin wraps up a mother—a woman (wiser now)—with dreams yet to be discovered—a life yet to be lived.

I feel strength and hope as I keep my chin up, knowing I may make more mistakes as I crawl, swim or stumble toward the Miracles and Red Flags, *but I will move ahead (carefully) without fear* as life and love fills me and draws me toward Wholeness.

*Do a risk, please, Jany.*
I'm so glad I did.

# EPILOGUE

*Sochi, Russia December, 2008*

I had a dream last night. A grey old couple was climbing a smooth hill under the full moon. I awoke. It was 4:40 a.m. and the full moon was above my cliff. It was cold in the room. I put on the warm clothing and waited the moonset a half an hour. I couldn't fall asleep because of that dream.

Suddenly I understood that the gray old couple were we—Calamity and the Russian.

# Calamity Jan and the Russian
## NOTES

Chapter Two
    1. Lynn Visson, *Wedded Strangers The Challenges of Russian-American Marriages* (Hippocrene Books, New York, 1998), Introduction p.
ix
    2. Ibid., p. 115
    3. Ibid., p. 61
    4. Ibid., p. 53
    5. Ibid., p. 199
    6. Ibid., p. 206

Chapter Three
    1. Ibid., p. 196

Chapter Four
    1. Ibid., p. 195
    2. Ibid., p. 125
    3. Deborah Tannen, *Talking from 9 to 5; Men and Women in the Workplace: Language, Sex and Power* (New York: Avon Books, 1994), p. 238
    4. Stewart and Bennett, p. 67: "The American emphasis on problem solving construes disagreement as a negative factor that must be solved . . . 'No problem' is synonymous with 'I agree.'"
    5. Colette Shulman, "The Individual and the Collective," in *Women in Russia,* ed. By Dorothy Atkinson et al (Stanford California: Stanford University Press, 1977), p. 381.
    6. Visson, p.116
    7. Ibid., p. 116
    8. Ibid., p. 117
    9. Mark Popovsky, *Na drugoi storone planety,* (Philadelphia: Poberezh'e, 1994) pp. 246-47

Chapter Five
1. Lee Jampolsky, *Healing the Addictive Mind,* (Berkeley, California: Celestial
Arts, 1991), pp. 88-8
2. Gloria Steinem, *Outrageous Acts and Everyday Rebellions* (New York, Holt, Rinehart and Winston, 1983), p.135.
3. Jill Boldt Taylor, *My Stroke of Insight,* (New York, Viking, 2006) p.122

Chapter Eight
1. Visson, p.115
2. Ibid., p.101
3. Ibid., p. 196
4. Ibid., p.203

Chapter Nine
1. Maria Wiederkahr, *Seasons of Your Heart* (New York, HarperCollins Publishers, 1991) p. 46
2. Florida Scott-Maxwell *Persimmon Tree*; Winter 2008

Chapter Ten
1. Robert Frost, *The Selected Poems of Robert Frost,* (New York: Holt & Company, 1930), p.43.

## About the Author

I'm the author of nine books for young readers and occasionally freelance for magazines including "Trip of a Lifetime," published January 2110 in *Arizona Highways* magazine and "Art Soars on Nature's Wings," published in the Winter 2011 edition of *American Style Magazine.* I hold a degree in Psychology and Criminal Justice from the Evergreen State College with post graduate studies in Psychology. Since the publication of my latest ghost town book series, I often speak to educators, community organizations and students about mining our own personal gold from the wealth of our inner resources. In classrooms and school assemblies I encourage young readers to go for that gold that lies buried in their wild and wonderful imaginations. I was an instructor with The Institute of Children's Literature and later taught independent writing seminars for aspiring writers throughout the state.

WEBSITE: www.calamityjan.com
BLOG: JanPierson.blogspot.com
FACEBOOK: http://www.facebook.com/jan.pierson.75

CPSIA information can be obtained
at www.ICGtesting.com
Printed in the USA
FFOW02n0947310714
6553FF